ip zip my br$_a$in harts

zip zi

my br_ain harts

Photographs by Angela Buckland

Kathleen McDougall Leslie Swartz Amelia van der Merwe

HSRC PRESS

Page **vii**	Foreword	
Page **ix**	About this Book	
Page **01**	Dysmorphic Series	
Page **07**	Looking at Disability	
Page **15**	Stickytape Juice Collection	
Page **23**	Loving Subterfuge	
Page **29**	Where's Nikki?	The complete installation
Page **33**	Encounters with the Medical Profession	
Page **45**	Where's Nikki?	The outtakes/single images
Page **75**	Family Dreams and Nightmares	
Page **83**	Shadow Catching	
Page **89**	Acknowledgements	
Page **90**	References	

Photograph by David Goldblatt

Foreword

It was two years after I lost my arm in a bomb blast that I discovered I was disabled.

I had known, of course, that with a short right arm I looked different, even freaky. I had battled, with some success, to get medical professionals to engage with me as a whole person and not just someone with an instrumental defect to be hidden or minimised; I had even written a memoir on the process. But it was only when I met with leaders of Disabled People South Africa (DPSA) that I began to call myself disabled. It was 1990 and they had asked me to advise on how to advance the rights of the disabled in the new Constitution. 'What you must do...' I said. 'What we must do...' I continued. In shifting from 'you' to 'we', I quietly joined what I have come to call the 'great democracy of the disabled'.

This book emanates from the democracy of the disabled. Don't expect a work about difficulty to be easy. The whole point about disability, whether visible or invisible, physical or mental, is that nothing fits. The book undertakes intensely complex and open-ended explorations of the meaning of mental disability for all those directly affected, children, parents, the community. The journey is atmospheric, sharp and engaging of your wits. Everything about it is deeply textured and deliberately unfinished. It has no clear beginning, middle and end, no denunciatory or triumphant outcome. What matters is the ground covered, the emotional, intellectual, psychological, and visual spaces passed through, not the conclusion. There is no conclusion. The book neither uplifts nor casts down, but troubles and soothes and fills you with enduring poetic wonder.

This is a most remarkable piece of visualised literature. The relentless objectivity of the feelingless camera engages with the intense subjectivity of the richly emotional camera operator, who in the case of Angela Buckland is also a parent/participant in the field being imaged and imagined by her. The text obeys the formal rules of grammar and the strict discipline of scientific cadence, and yet bursts with the energy of powerful and engaged intellectual emotion. Can disjuncture be captured with a coherence that does not destroy the very thing being depicted? Is clarity the enemy of integrity? Can all these jarring elements coexist in a single beautiful whole? I will only have the answers to these questions when I place the fingers of my surviving hand around the completed book, which I am eager, indeed greedy, to do as soon as it appears.

Justice Albie Sachs Constitutional Court of South Africa, 2006

'every parent's secret dread is a 'dodgy' child'

ANGELA BUCKLAND

About this book

The secret dread that photographer Angie Buckland speaks of wells from an all too recognisable anxiety about the world of disability. It seems, often, to exist beyond a barrier of thinking and seeing that encloses disabled people in silence and obscurity.[1] Yet it is a world in which the fullness of human life, with all its joy, pain and confusion, is no different from the life we all share. In that sense, this book is as much about us as it is about disabled people and their families.

It is a challenging book, and it is meant to be. We want it to challenge you, just as making it challenged us, because one of the things that is clear about disability and all that goes with it, is that it is complex and demands a personal – and not always comfortable – response.

Zip Zip My Brain Harts is the result of an unusual experiment – a collaboration between Angie Buckland and researchers interested in disability issues. Buckland is the mother of a disabled child, Nikki, and her photographs in this book are part of the work which she has done, and continues to do, to make disability, so hidden from society, more visible and accessible to us all.

When Buckland approached us to work with her on this book, we were very excited at the opportunity to break free from the usual boundaries of research, which tend to limit the reach of ideas that could enliven social debate and even change how we live to the relatively small audience of academic journals and books. The quality and emotional impact of Buckland's work gave us a chance to try something different, and new – to speak to a broader audience, in a different way, and, with Buckland, increase public awareness of the needs and human rights of disabled people and their families.

Like all boundary-breaking activity, the process of producing this book has been testing to us all, as much as it has been stimulating. We have debated endlessly what this book is and who it is for. Our common goal is to further the human rights agenda for disabled people and to contribute to a more barrier-free society for us all, but what is this book exactly? Is it a photographic book which happens, unusually, to have some text written by social scientists, text dealing not only with the images but also with the issues the images speak to? Or is it a social science book which happens to have photographic images interspersed with the text? Who is the book for? Is it for people interested in photography and art, or for parents of disabled children, or for people in the health professions who come into contact with childhood disability? Or is it for people interested in human rights, and in South Africa in particular?

We are impelled with conviction, to say that this book is 'for everybody', not least because building an inclusive society in which all people have the chance to reach their maximal potential should be everyone's concern.

Mulling over the questions about who the book is for, we have come to see it as being a bit like the issue of disability itself. Disability is everywhere – every person has some connection to disability, and everybody at some time will have an experience of being disabled in some way, even if for a short time. Yet disability is so hidden from society, so little thought about and seen, that it often seems that disability is nowhere. Stereotypical images perpetuate the view that disability is about some people only – not about the nondisabled 'us', but about the disabled 'them'. Yet, as we have said, disability is no less about the fullness of human experience, with all its joy, pain, and confusion.

Buckland's images speak for themselves, and do not necessarily need text to explain or interpret them. The strength of the photographs is that they can be read and experienced in a range of ways and each person's response to them will be unique. Our task was to add words to an already articulate and powerful compilation of visual images. Our intention with this text is not to present an analysis of the images, but merely to show how thinking about images and representation, and thinking about Buckland's images in particular, can help us find a way into thinking about the experience of disability for children, for parents, and for those who help them. We expect and hope that readers will have their own unique and personal responses to the photographs.

Most of the images come from three sets of photographs featured in this book – the 'Dysmorphic Series', the 'Stickytape Juice Collection' and the 'Where's Nikki?' installation. The 'Dysmorphic Series' focuses on Buckland's early experiences of being a mother of a disabled child – she superimposes x-ray images of Nikki on other photographs she has taken of him, and through this work, explores the complexity of the relationship between her family and the medical profession. The arresting title of the second set of photographs, 'Stickytape Juice Collection', like the title of the book, comes from the writings of a disabled child she knows and whose family she has photographed. The child has cerebral palsy, but Buckland, by using his words so prominently, draws us to the truth that he is more than just a disabled child – he is a person who loves, and is creative with, language. Stickytape juice does not, of course, exist, but this boy used the term when listing his fantasy of favourite juices, moving from the known world of strawberry juice, for example, to the fantasy of a world where sticky tape juices exist. The 'Stickytape Juice Collection' is a series of photographs of clothing altered by loving adults to conceal aspects of children's disabilities – dribbling, walking with calipers and being unable to do up buttons on school clothes.

For the final set of photographs, entitled 'Where's Nikki?', Buckland moves further from the domain of the body as site for disability to the realm of family relationships. In the 'Where's Nikki?' installation – named for Nikki's tendency to run away a lot – Buckland has worked with her own family and with five other families to create seven huge photographic works that interpret different aspects of the life of families with disabled children. Writing about her work on disability, Buckland has said:

> 'Where's Nikki?' and the 'Stickytape Juice Collection' focus on a quietly marginalised subject and are presented in a public space in order to articulate the submerged, concealed and silent anxieties that families of disabled children experience. The consumerist notions of idyllic childhood promised by Pampers Nappies and Woolworths advertising are disrupted by the disclosure of disability, accompanied by fraught emotions. David and I are the parents of Nikki and Christine. Nikki is an undiagnosed child with special needs. Being a parent of an undiagnosed child can be a frustrating and confusing experience. Every spectrum of human emotion is played out on many levels. Each situation is different and varies according to the severity of diagnosis. There is only one certainty: uncertainty. Every parent's secret dread is a 'dodgy' child.

We interviewed and interacted extensively with Buckland herself, and we also interviewed the families portrayed in the 'Where's Nikki?' installation, all some years after the original photographs were taken. Not surprisingly, families had moved on, issues had changed, new concerns had arisen, new achievements had been celebrated. Our intention with this text though is not to capture as 'case histories' the families with whom Buckland has worked. We are not trying to convey their particular stories. Instead, we have the privilege both of Buckland's work and our interview material to make some more general points about disability and the family, and about disability and parenting in particular. We make no claim (and nor does Buckland) that the families with whom she worked are 'typical' in any way. Of the six families, one is Zulu-speaking South African, one Indian South African, and the remaining four are white English-speaking South African, to name one obvious way in which the families are not typical of South Africa.[2] We also make no claim that the issues the families chose generously to discuss with Buckland and with us, cover

everything, or even the most important things, about being families with disabled children. Instead, the families provide a living way into thinking about things which are of much more general concern to us all — about how to create a more inclusive and caring society.

Social scientists and photographers obviously work differently. One of the most obvious differences is that social scientists generally try to disguise the identities of those with whom we work — we give pseudonyms, we do not photograph, we make abstractions about people's identities. The psychologist Erik Erikson has commented on the irony that in our writings we are often very interested in identity, but the first thing we do to protect confidentiality is falsify the identities of those we write about.[3] Photographers like Buckland often do something different — they photograph actual, recognisable people, yet the images are often not about their identities, and go beyond the actual photograph. In our work together, we all struggled with the question of identities — what could (and should) we say or not say, given that there are a limited number of identifiable people photographed in the book? Even where people had agreed to being photographed, being interviewed and being quoted — and all the adults had — what were our responsibilities to the people we spoke with? How could we avoid turning them into 'cases', making people into objects — objects used to make general points and stories about human lives, stories which would diminish or disrespect the privacy and individuality of the people photographed? And what of the children photographed? None of them has had a say in whether they want to be in this book. How could we respect them while using their images and stories to make a more general story about disability? None of these issues is simply resolved. In preparing this book, we consulted many people for help, among them Valerie Sinason, who has done important work on developing a human rights approach to people with intellectual disability.[4] Valerie suggested that we keep in mind how the text would appear to the children themselves. What would they make of it? What may they make of it when or if some of them come to read it in the future? We decided on the basis of our discussions with Valerie and others to delink the text from specific photographs and to make general points rather than specific ones with the interview material we have. We also showed the text to the parents concerned, and allowed them to veto any representations they felt were hurtful or unhelpful. But this remains uncharted territory.

This brings us back to saying that this book really is an experiment for us all, an adventure in making something hidden visible. We hope that the photographs and the text will encourage thinking and debate, disagreement and even anger, perhaps. These emotions all engage and change us, and are preferable to the invisibility and silence which so often obscure the realities of the lives of so many.

Kathleen McDougall, Leslie Swartz and Amelia van der Merwe

1. We have chosen to use the terms 'disabled person/people' and 'disabled child/ren'. While there are good arguments for using the terms 'person/people or child/ren with disabilities' (which prioritise personhood over disabled status), the former are more commonly used in South Africa. We also understand the term 'disabled person' to reflect the ways in which people are disabled through their interaction with social systems and not simply by a physical or mental condition.
2. We acknowledge that these racial categories are problematic, informed as they are by their roots in apartheid's racial classifications. Neither are they good indicators of how people may reflect their own identity; for instance, many white and Indian South Africans also describe themselves as Africans and many prefer to describe themselves in cultural terms such as English, Afrikaans, Hindu, Moslem or Zulu.
3. Erikson, 1971.
4. For example, see Sinason, 1992 and 1993. Sinason also co-wrote two books with Sheila Hollins and Beth Webb for people with intellectual disability who have been sexually abused. See Sinason et al., 1993 and 2005.

dysmorphic series

I produced the 'Dysmorphic Series' during a Nordic cultural exchange project, known as 'Shuttle 99'. This work marks the beginning of my photographic exploration into disability and what it means to parent a disabled child. I found a new subject to explore – one so 'close to home' – it was cathartic at a time when Nikki was being subjected to endless medical investigation. These images were taken during the peak of these investigations, C.A.T. scans, M.R.I. scans and x-rays, in the hope of establishing a diagnosis, waiting/hoping for the elusive answer. As a family, parents and as individuals we were subjected to endless mental, genetic, medical and emotional probing. It was complex. A retired psychologist spent two years trying to assist us on a daily basis to demystify Nikki's condition, silent family histories were exposed, our privacy raided and some difficult exchanges took place.

These are difficult images because of their duality; tenderness coupled with medical exploration. Each image derives its medical title from a particular physical 'abnormality' Nikki presents, known as 'dysmorphia' in the medical world, double exposed with x-rays of his skull.

Angela Buckland

Maxillary Hypoplasia

Simian Crease

Sacral Sinus

Trigonocephally

'you funny little red batswana egg'

LUKE OSBORNE age 11

Looking at disability

This book is, in a sense, a disclosure of something secret, of something hidden. The photographs are public expressions of the sometimes painfully private experience of being the parent of a disabled child in South Africa. It was photographer Angela Buckland's intention 'to try and get under the skin of parenting a disabled child – [to express] the unspoken anxiety and all the secrets'. Elsewhere she writes about the 'submerged, concealed and silent anxieties' that 'every parent's secret dread is a dodgy child'.

There is a tendency for disability in South Africa to be a secret. The challenges that face families of people with disability are also often hidden away. Part of the reason for this secrecy may be that disability is sometimes seen as a shame or a disgrace, something to hide away, a source of stigma. These reactions are rooted in the idea that disability is freakish or monstrous, an idea that continues to haunt the ways in which disability is seen, and to affect the experiences of disabled people and their families.

But what if disability were considered ordinary or everyday? What would looking at disability be like then? What if disability were considered not so much as the sign of incontrovertible difference, but as just one among many differences that there already are between people? It is a way of seeing that is encouraged by the disability activists we spoke to. One said:

> For me, we are just ordinary people, really. We have one sense or another that doesn't work in a way that yours do.

Another said:

> The disability is really just an impairment of an aspect of a task: the capacity to do something; whether it's to see, whether it's to feel, whether it's to run, whether it's to speak.

There is also, however, something important in how many disabled artists make their disability so prominent in their work – insist, as it were, on a kind of spectacular display of themselves.[1]

> My withered limb is who I am. It is right for me. I am who I am.[2]

It may seem contradictory but there is something about claiming an ordinary complicated identity – one that is about more than just being disabled – that involves entirely claiming your disability. Being visible, both culturally and politically, is about being visible both as disabled and as more than just disabled.

'Freaks', 'monsters' and 'curiosities'

Buckland's photographs of the children are very different from the ways in which disabled people have historically been represented visually. Pictures of disabled children often display them as medical 'cases', curiosities, freaks or monsters. Disabled children are often photographed in relation to being patients in hospitals, and sometimes such photographs also portray them as freakish. The picture on page 08 was taken in the 1870s in the United States, and shows conjoined twins, aged six months. In some ways the photograph seems a portrait of these particular children,

but the reason for taking it was to record an interesting example of a pathological condition: the photograph was used to record the children as specimens rather than as, for example, daughters. In this way, some of the children's individuality is obscured by the purpose of the photograph. Let's think for a minute what it must be like to be photographed as a medical case. The reason you are there is not to be photographed as yourself, but to stand for a medical condition. People who appear in older medical photographs are commonly nameless, or are sometimes given a pseudonym. Because the photograph is of the condition and not of the person, sometimes only the name of the condition is noted.

Still, there are traces of that personal identity left in the photograph, and this is what makes some of these early clinical photographs so poignant – the sense of that intimate moment between the photographer and the person being photographed. Sometimes in these photographs there are hints of the individuals' profession in the clothes they wear. This creates a tension between being seen in one way – as a case – and not seen in another – as an individual with a story which is not only the story of a case.

Author, Anna von Senger, has described the excitement of discovering a collection of early clinical photographs, of how they bring with them a tantalising sense of the past:

> When I opened the box, I discovered little packets wrapped in cellophane. I opened one of them. It contained images of men, women and children with unspeakable faces. The box exuded a strange smell, intoxicating but different from alcohol. I was electrified...[3]

Part of the fairytale quality of the lost box of photographs is the sense in which they are haunted by these other everydays.

In writing this text, we struggled with the ethics of showing photographs like the one of the conjoined twins. To what extent are we reproducing the very problem of representation we are grappling with? There is a good argument for showing certain images in textbooks for the education of health professionals, though even this tradition of representation may be very complex and determined not only by the need to educate. But what justification can we have in reproducing such images in a book that has a wider readership? In order to protect the confidentiality of living people with disabilities we have chosen not to reproduce any of the many contemporary clinical photographs of disabled people. But the difficulties remain – are we being disrespectful to twins born in 1870 and long since dead? Is there any way to represent disability visually that is not spectacular, stigmatising or sensationalising?

Perhaps part of what makes the photograph of the twins disturbing – because we *do* find it disturbing – is that it does not look 'clinical' enough. The tradition of clinical medical photography is by now very well established, and even those of us who have never studied medicine know what kinds of images to expect in medical textbooks. We have seen them up on posters in consulting rooms of doctors, dentists, and optometrists. We have seen them in advertisements for toothpaste or back-pain medication. But in the early days of medical photography people struggled with how to make a clinical photograph, and with how to signal to viewers that this was a clinical photograph and not a portrait.[4] There is a sense of that struggle in the picture of the conjoined twins: it appears to be a portrait that is being used for medical purposes, yet it seems to show the twins' extraordinary body as freakish.

'Badly shaped'?

If the picture of the conjoined twins has the appearance of a portrait that is being used for medical purposes, Buckland, in the 'Dysmorphic Series', uses medical photographs expressly to create a portrait of her son. It is interesting to think about the problems with the photograph of the conjoined twins when looking at this series, in which she superimposes portraits of Nikki on x-rays of his body. In these pictures she engages directly with some of the problems of seeing disability – both in the sense of looking at disability and in the sense of perceiving disability.

The word 'dysmorphic' means 'badly shaped'. It refers to physical characteristics that are unusual. An example of a dysmorphic feature is having only a single crease across the palm, known as a simian –'ape-like' – crease, a feature which, for instance, people with Down syndrome have. The x-rays reveal to people skilled in reading these images what is inside Nikki's body – what makes him physically extraordinary. To the unskilled eye there is something alienating and even terrifying about such images of the inside of a body.

Although such images were at one time mostly limited to medical textbooks, it has become more common to see them outside this context. Perhaps exactly because pictures of our insides are mostly associated with the clinical, it can be an alienating experience to view such images. To the untrained eye they are virtually featureless – they could represent anyone. Of course, in some cases medical pictures of specific bodies are meant to be examples of what we all look like. Nevertheless, the pictures can still be read as showing individual physical features, and so are not featureless or universal to the trained eye.

An important exception to medical pictures that seem alienating or terrifying may be the ultrasound image of a fetus in the womb. Such pictures are often given similar status to other more ordinary pictures of babies – they may be framed or placed in photo albums, shown to family and friends. Buckland achieves something similar with Nikki's x-rays when she re-images the somewhat alienating medical images by superimposing on them her own portraits of him. We may speculate that in doing this she takes some control over a process that is beyond her control – the medical diagnosis of her child. Certainly, this is a difficult process for parents and caregivers[5] and for doctors, a subject we discuss more closely later.

Some parents find that the medical view of their infant as having dysmorphic features overrides their own view of a child who is good to look at:

> I mean, I think my son was so handsome and then he [the doctor] just ripped apart his face. 'He has all these dysmorphic features. His eyes are widespread. He has no bridge on his nose. His ears are too low. He's got what they call a shawl scrotum, and he's dwarfed in size,' and all of that...I felt like I wanted to wring my own neck because I would look at my son and find myself thinking —'Oh, my God, he does look like that.' It was awful.[6]

Some parents find that the medical way of seeing is dehumanising. As a mother of premature twins puts it:

> Right after they were born, I remembered having read an article discussing the cost-effectiveness of saving babies that are below a certain number of grams at birth and I remember thinking: 'But they aren't grams. They are Emily and Ryan. They are beautiful and they are mine!'[7]

Looking at Buckland's 'Dysmorphic Series' alongside personal accounts like these, it seems that the photographs are about claiming ownership over how Nikki is seen. Certainly, she does seem to be insisting that there is more than one way of seeing him — from the outside as well as from the inside.

In the image titled 'Maxillary hypoplasia' (page 02), Nikki's sleeping head is enclosed inside the picture of his skull. He is turned inside out and the effect is disturbing. Although he seems peaceful and safe inside the skull, the skull itself suggests some kind of horror, even death itself, as in the skull and crossbones we associate with pirates or with warning labels on toxic or dangerous substances. It is not clear whether the sleeping infant is haunted by dreams of death, or whether it is the skull that is haunted by a sleeping infant. The stark comparison of these two ways of seeing Nikki is shocking. Other photographers have claimed ownership in this visual way over a medical process. Most notable is Jo Spence who took pictures of her own body in relation to her breast cancer.[8] These photographs reclaim her way of seeing her own body. Spence insists, like some disabled performers, that her body is her own and also that it is not something to be hidden away.

Buckland's pictures are different from these more confrontational dialogues with medical ways of seeing. She uses the same medical terms as the doctor does to describe aspects of her son. Her photographs, like the x-rays, also record his physical idiosyncrasies. Her images are, like the doctor's, of Nikki's dysmorphic features. However, there is none of the sense of revelation here that there is in the image of the conjoined twins. There is less of a sense of surprise at Nikki's difference, than the shock of being let in on his mother's contemplation of that difference.

Producing a thrill

The picture of the twins has a sense of thrilling revelation — it presents disability as the revelation of something secret. The little girls' extraordinary shared body is unwrapped for the viewer.

One can almost hear the fair barker's voice: 'Step up, ladies and gentlemen!'[9] The image is titillating and we feel complicit in some kind of violation. This image, and others that are far more shocking, form an important part of our cultural understanding of disability. The idea of disabled people as freakish — the freakish images that invite violation — is part of our heritage. Understanding how Buckland challenges this tradition and how she contributes to new ways of seeing disabled children is really possible only through understanding what went before, the conventions she is up against in her work.

The picture of the conjoined twins reveals some of the uncertainties of medical photography in the late nineteenth century. It also reveals some of the uncertainty around how to understand disability: as freakish entertainment and as medical pathology.[10] Investigating the pathological was sometimes, simultaneously, a display of freakishness. Similarly, the display of freaks borrowed the language of science, and sometimes hospitals provided a setting for an entertaining revelation of freakishness. It was possible, for instance, in nineteenth-century London to take a tour of the psychiatric hospital popularly known as Bedlam. It is still common practice for health educators worldwide to display patients so that trainees may learn to recognise different forms of pathology. Anyone who has worked in a teaching hospital will recall the frisson when a patient showing rare symptoms is admitted. Trainees are commonly encouraged to seek out the patient or are shown the patient in a formal ward round or case conference. This occurs with good reason – the trainees, having seen the unusual pathology, may be better equipped to recognise it in later clinical practice. But how might this feel to the patient, or to the patient's family? The possible value of seeing someone suffering from a pathological condition in this way is offset against how the patient may experience this event as objectifying, dehumanising and even terrifying.

One disabled person we spoke to said that people were so used to seeing disabled people as exhibits that it was difficult to claim a voice. This activist with a mobility impairment described what happened at a lecture she was giving: 'The comment was "we thought you were the exhibit for the lecture, and we were waiting for the lecturer".' She says that people who are not disabled sometimes find it difficult to believe that she can speak for herself:

> People don't see you as a person or what you can contribute to society. They see the wheelchair, and as a result of being in a wheelchair, they then don't speak to you as a person. If you happen to be with non-disabled people, they then talk to them and use them as your mouthpiece. Or, alternatively, they use a special voice, which in my case will go something like this: 'So how are you?' You know, like I'm two years old. But I'm a woman of substance with a very definite mind of my own.

There is a theatrical thrill in disclosing what is hidden in a display of illness or disability. There can be disgust, but also fascination. The display relies to some extent on the otherwise hidden nature of what is considered freakish. What makes such displays thrilling is the revelation of something that is hidden. A curtain is drawn and 'tah-dah!' the extraordinary body is revealed. Without there being something hidden, there is no revelation. Hiding and display can be used to titillate and may also form part of medical education – through something like a circus act, trainees can be helped to remember something important clinically.

We are reminded of a case conference in a psychiatric hospital in South Africa in the 1980s. A patient was brought into the room very warmly dressed (it was winter at the time and the warm clothes and the large scarf around the neck did not seem unusual). The patient was extremely anxious, and the professor who was conducting the case conference encouraged trainee clinicians to speculate on the psychological bases of her anxiety. Towards the end of the conference, however, the professor dramatically removed the scarf from the patient's neck to reveal a huge goitre – a large lump on the thyroid gland – forming a distended lump on the neck. Thyroid dysfunction is commonly associated with profound mood changes, and the professor was making the unforgettable point that a good health professional must always consider the possible – and, in this case, treatable and reversible – physiological basis for mood disorders. Good psychiatric treatment does not ignore the body. But the way in which this important clinical lesson was taught mimicked the excitement and the trickery of the magic act or freak show. Who knows how the patient herself felt about being used in this way?

The first thing we have to recognise in thinking about this dilemma is that there is, of course, something exciting and thrilling about medicine in itself. As we discuss in more detail later, we are taught to think of doctors as miracle

workers who can overcome tragedy, replace sickness and misery with health and vigour. Historically, and in many contemporary health systems, there is a close association between health care, healing rituals, and magic. Part of why we admire doctors and healers so much is that they can transform people, sometimes before our very eyes – as we see in countless television shows about doctors. Where do we draw the line between what is medically necessary and what is simply what disabled photographer David Hevey calls 'enfreakment' – making people look freakish?[11]

In the late nineteenth and early twentieth centuries, photographic and live displays of disabled people, freak shows, relied on making physical difference seem as outrageous as possible.[12] 'Giants' were so much more gigantic next to someone short. These spectacular displays of disabled people as freakish, or monstrous, tended to reduce people to a single aspect of their identity. Such displays make it all about a physical characteristic. In producing the spectacle, someone's complex reality is reduced to a very simplistic, if fabulous, tale. These displays, then, are also a kind of hiding and secreting away of someone's complex humanity.

Some of the thrill of the spectacular display lies in the fact that most disabled people were hidden from view. The belief that unusual bodies and minds are so awful that the rest of society must not have to encounter them is illustrated in the picture below from a series of newspaper photographs taken in 1915 of the leper colony on Robben Island.[13]

Another image in the series is captioned: 'Among the female lepers – the less unsightly consenting to be photographed.' Here, hats and veils obscure the subjects of the photograph. Most of these photos were taken at some distance and it is impossible to tell much about the features of the people in them. Children are not featured at all except in a photograph taken at some distance from the children's ward. The pictures reflect a horror of being seen that speaks volumes about the self-regard of the people being photographed. They also reflect the horror of seeing, and the idea that being physically different is monstrous, that physical difference must be hidden from view.

LEPER BOYS BOLTING FROM THE CAMERA. ONE HAS COVERED HIS FACE WITH HIS HAT.

There are powerful stereotypes which portray disabled people as monstrous or freakish. One disability activist describes, for instance, the beliefs that some people have about epilepsy:

> They believe that people with epilepsy are of a lower intellect, that they're evil spirits, that they're demons, that you can catch it if you stand too close, and literally that it's contagious. Ag, there's so many. Basically, that you can't do everything that other people can do – that you can't get a job, that you can't play sport, that you can't go to a mainstream school. All the 'can'ts' that you can think of can basically go in there.

These stereotypes have a real impact on disabled people's quality of life, as well as on their access to basic services and to employment. It is no surprise then that disabled children's parents sometimes feel that they want to hide their child's disability – as much for the child's sake as for their own. Confronting their own and other people's reactions to physical difference, to what is perceived as their freakishness, is a real part of life for families with disabled children.

1. An excellent example is comedian Greg Walloch who has cerebral palsy, and whose 'in your face' film *F**k the disabled*, (Kabilo & Walloch, 2001) plays on his disability.
2. Siebers, 2001, p. 30.
3. Naruyama, Ishida & Von Senger, 2004.
4. Fox & Lawrence, 1988.
5. We acknowledge that some disabled children are looked after or brought up by people who are not their biological parents, but are parents to them in every other sense. For ease of reading, we use the term 'parents', with a few exceptions, to cover both biological parents and caregivers playing a parental role.
6. Landsman, 2000, p. 176.
7. Landsman, 2000, p. 176.
8. Hirsch (1997, p. 139) writes of Spence's work that she 'steps out of a representational tradition, which depicts the ailing person as one who copes and suffers; in her images the ill person acts. She not only graphically records her scars and her semiconscious body laid out on stretchers and monitored by x-ray equipment, she also deliberately fragments that body, thus reproducing medicine's relationship to a body in parts and exposing its disregard of the integrity of a person'.
9. See Ostman (1996) for a sense of how freak spectacles were produced.
10. The manner in which these two ways of understanding enable each other is beyond the scope of this book. Thomson (1996) introduces the issues and Grosz (1996) provides a discussion of how the fascination with specific kinds of 'freakishness' plays into broader social concerns about subjectivity.
11. Hevey, 1992.
12. Mannix, 1996; Thomson, 1996.
13. Robben Island is an island off Cape Town which, in the nineteenth century, was used to isolate 'lepers, lunatics, and the feeble-minded' from the rest of society. It later became famous for its prison where Nelson Mandela and other political activists were incarcerated. The history of the island itself shows something of the continuity between disability issues and other issues of power and politics. The use of the term 'boys' in the caption to describe the black men pictured also places the photograph in terms of the racial politics of the time.

stickytape juice collection

In the photographs that follow, articles of clothing were handmade or altered to mask the child's 'difference', and to assist them with their particular physical challenges. These items were difficult to source and not readily available. Another cover-up in the silence around disability. The T-shirts belonged to Nikki when he was a toddler and mark my first encounter with social intolerance. He used to dribble noticeably and gradually the stains worsened on his shirts. One of his early speech therapists used to wipe his mouth repeatedly while she worked with him. I found this unfamiliar and confusing. I was not sure what my role was as a mother with non-family members, apologise, wipe or leave alone? My mother made some brightly coloured shirts with disguised bibs stitched underneath. This was an extraordinary act of love and highlighted the reality of the situation; he wore them a lot and they served a purpose. He grew out of them and I forgot about them – but I kept them and never passed them on to anyone (as is the norm with parenting). Some years later I discovered other articles of clothing adapted by mothers specifically for their children – subtle cover-ups of their children's physical struggles – in an attempt to seek a form of acceptance. For me, these items of clothing symbolise acts of extraordinary – albeit unacknowledged – compassion. I have represented these articles of clothing in a way that celebrates their uniqueness. And rather than represent them as items that attest to difference, otherness, perhaps even shame, I felt they deserved a different approach, perhaps even a glamorous one. I was mindful of the consumerist notions of idyllic childhood promised by Pampers Nappies and Woolworths advertising which are disrupted by the disclosure of disability. The title of the work is from the biographical writings of an eleven-year-old cerebral palsied child, Luke Osborne.

Angela Buckland

Page 16

Page 20

'it's from your side of the family'

ONE SPOUSE TO ANOTHER

Loving subterfuge

Attempts to make disability less apparent form the theme of Buckland's 'Stickytape Juice Collection'. The image on page 19 is of a colourful T-shirt turned inside out, revealing a secret bib.

This is a loving grandmother's attempt at hiding the child's dribbling – inappropriate at his age. Buckland compares this in the series to other families' loving attempts to make life easier for their children and for themselves: calipers attached to 'ordinary' shoes from Woolworths so that a child looks more like other children his age (page 21), and velcro replacing buttons so that someone who can use only one hand can open and close the pants without assistance (page 16).

The loving acts of subterfuge depicted in 'Stickytape Juice' are linked to the tremendous pressure parents feel to enable their child to 'fit in'. One family made a point of saying how pleased they were that their disabled child's cousins socialised regularly with him. They told of their anxiety at social occasions, about the risk of other people not coping with how their disabled son was sometimes inappropriately friendly:

> And you can tell immediately...the one group, from the beginning, they know how to relate to him. They know how to talk to him. They absolutely love it. And then there's another group – and they just don't. And you can very quickly suss them out. And now, our debate is: do you leave him with those people? For how long? Two minutes? Five minutes? Three hours?...

The 'Stickytape Juice Collection' makes artefacts of everyday objects. Ordinary items that might never make it into museum collections are displayed in the images as important cultural objects, like exhibits in an ethnographic display. There is pride in this display, but – as with ethnographic displays – what is also on display is otherness.

This may seem paradoxical. After all, the relatives and friends who made these objects wanted to help the children fit in, not make them seem even more different. Buckland highlights exactly this paradox in these pictures – the troublesome desire that parents have for disabled children to 'fit in', and the problem that where they want their children to fit is a limited and limiting social space. The desire is troublesome because it negates certain aspects of the child, troublesome because it is impossible. In this way of seeing, the 'special' of a 'special-needs child' is the special of stigma, not the special of birthdays.[1] The parents' need for disabled children to fit in can also be a way of saying that they themselves do not think the child is good enough the way she or he is. This can be a very painful and limiting message for a child to absorb. Some disabled adults say they have felt that they were held back or slowed down by their own parents' inability to come to terms with disability.[2]

Talking back

It can be challenging to display disability proudly. One controversial way of doing this is for people who have been labelled as 'freaks' to take on a 'freak' identity and in this way to take control of it. In an esoteric publication, self-declared freak, Daniel Mannix, celebrates being freakish. He insists that there may be another way to 'read' the freak show – we can see it not as demeaning but as a way for people with extraordinary bodies to get attention, fame, to make a living and to gain self-esteem. For him, visibility – any visibility – is better than being hidden away.[3] Photographer Diane Arbus may also be said to celebrate what looks 'freakish'. For her, though, the freakish extends

beyond the physically extraordinary to the idiosyncratic ways in which people perform their identities; not just people of short stature, but the ways in which men and women make themselves seem feminine – Marvin Israel goes so far as to say that Arbus presents beauty as stigma.[4] South African photographers Roger Ballen and Pieter Hugo's work has also been criticised for rendering people freakishly. Ballen, like Arbus, defends his choices by relating stories of the close and supportive relationships he has with his subjects.[5] Arbus's comments about her relationship with some of the people she photographed seem particularly relevant: she says that 'freaks' had a 'terrific kind of excitement for me. I just used to adore [freaks]...I don't quite mean they were my best friends, but they made me feel a mixture of shame and awe'.[6] These artists' works are complex and interesting and not readily reducible to being morally 'good' or 'bad' – nor is their focus the relationship between bodies and society. However, it may be said that these photographers approach representing physical – if not necessarily cultural – 'freakishness' from the outside, and exploit, to a greater or lesser extent, the excitement of revelation.

Contemporary disabled performer Cheryl Marie Wade – who appears in the documentary *Talking Back* – is very candid about how her hands alarm people. In *Talking Back*, she waggles them suggestively and jokes about being the bogeyman. Similarly, disabled photographer David Hevey despises the coy freakishness of 1980s charity posters, and challenges himself to portray disabled people in ways that do not make them seem freakish, but without shying away from showing physical difference. His images of a disabled children's theatre group were made in collaboration with the children and, while the children's disabilities are clearly visible, they are not the whole focus of the images. For Hevey, as for many disabled artists, disability is an important part of the story, but not the whole story. The choice is not between being hidden or being displayed, but about being real.[7]

'Us' and 'them'

It is tempting to think of documentary photographs as the most truthful and objective way of depicting real life. After all, the camera records accurately what is in front of it. But in the process of making documentary photos, complex lives can too easily be reduced to one moment. The one moment that is chosen is often the one that fits best with what already seems to be true. So, for instance, poor people are commonly pictured as living in squalor. Historically, documentary pictures depict those who are marginalised – through poverty, for instance[8] – and, although the pictures may alert viewers to poor social conditions, they often sustain the disempowerment of the people in them.[9] They do this by sustaining a comforting sense of difference between 'us' and 'them'. Often, some of the (guilty) pleasure at looking at documentary photographs arises from the viewer thinking 'at least my life is better than this'. Where one feels pity for those depicted, there can be a great deal of 'safety' in looking at pictures of misery. We may even find ourselves blaming people for their suffering, thinking that they must have done something, or they must 'be' something, to deserve being in a situation worse than our own. There can be a voyeurism to documentary photography that, we argue, is similar to the titillation of the freak show.

In any portrait, there is a certain transformation, when an actual person is transformed into a representation of him or herself. In the case of freak displays, the transformation is intended to accentuate the 'freakish', emphasising whatever is unusual, and obscuring the ordinary.[10] There is a very selective representation of whatever is considered different, and in the process the whole person seems unusual, freakish. In intending to show how disability is distinct, it is possible for it to seem that disabled people have nothing at all in common with anyone else. The image of the disabled person or the freak as 'different' can help to make the viewer feel more 'normal'. If we look at a picture of giants, for example, we can quietly say to ourselves, 'They are the really odd ones; I don't have to worry that I am too tall or too fat, that I don't feel as strong as other people – when I look at these freaks I realise I'm normal after all.' In our image-driven society with its focus on appearance, objects and wealth as indicators of worth, we all have anxieties about whether we are normal enough, about whether we fit in. We can use images of the 'freak' against

which to measure our own normality. In looking at freaks we can be soothed that we do indeed fit in – the freaks are those who inhabit the world of the 'other', of the bad dream. The distance between spectator and what is on display is critical in creating the spectacle of the unusual body.[11] In other words, for there to be a 'freak' there needs to be someone who is 'normal'. In reality, though, we all know that there is no neat line between 'normality' and 'abnormality' – although we may have a lot invested in being on the normal side. Similarly, there is no line permanently dividing disabled people from those without disabilities, and it is inaccurate and simplistic to think of disabled people as an intrinsically separate population. Disability-studies theorists, Breckenridge and Volger, argue that, 'no one is ever more than temporarily abled'.[12] Disability is not a static experience. It is also not something that is generalisable among people with the same disability. People may experience varying degrees of disability, or more than one kind of disability, and may have different experiences of their disability from day to day. When we photograph disabled people, we run the risk of hiding all this variety.

Buckland challenges dehumanising ways of seeing disabled people only in terms of their bodies. For instance, in the 'Where's Nikki?' installation, (page 30–31), and the single images (page 46–73) by placing the children so firmly in the context of a family moment – whether of joy or despair – she acknowledges that in some very important ways the experience of impairment is made better or worse through social context. Disability is not static and separate from the resources you have access to, or to your own or others' prejudice about it.

The children featured in Buckland's 'Where's Nikki?' installation have a range of disabilities, some very severe and others less so. One child has been diagnosed with pervasive developmental disorder, one has Asperger's syndrome. One has cerebral palsy with left hemiplegia, and also has epilepsy. One is blind with cerebral palsy, no speech, no leg movement and is cognitively impaired. One has a mobility impairment. Nikki has no diagnosis; he has been described as 'low functioning'.

Looking at the pictures it is difficult to match the children with their disabilities. Their identities are masked, but not in the way conventional 'medical' pictures of disability mask identity – for example, by placing a black strip on the picture to obscure the facial features. Much more importantly, in most cases the child's disability is not depicted, only alluded to, and the children's disabilities are not the focus of their portraits. This is to some extent a political position that Buckland takes. The children are not reduced to their disabilities, to being collections of impairments, (poorly) assembled bodies. Perhaps this is frustrating. The viewer may ask, 'But where is the disability?' Instead, here we see the children as their own people, and as part of the complex social structures of families with unique histories. There are some ways in which the pictures are difficult to read because they refer to stories. We want to ask, 'Why are there shoes floating around Jonathan's head?'[13] (page 31) and 'Where is Nikki running to?' (page 58). We are conscious that there is more outside the frame of the image, that this is not the whole picture. There is room for imagination in not knowing the whole story, and for the realisation that this is not the whole story.

Buckland's images of the children show a sensitivity to the child's particular disability as well as expressing something of the child's personality. The child comes across as more than pitiable, and as more than a disability. The image of Osman shows him tracing a TV screen, as if he can feel the letters with his fingertips (page 61). On one level this refers to how Osman himself is enchanted with the technology of the TV and video machine. But the picture also makes sense in terms of the search for meaning that is depicted in the 'Where's Nikki?' installation. Osman's delicate fingers seem to be tracing a line of thought – something just out of reach, something he can almost touch but for the screen intervening. The image of Matthew shows his face in an unusual perspective (back cover). The side that is almost obscured from view by shadow is the one that is in focus. Although it is in close-up and we feel that we are standing very close to him, he is not completely visible. While we see him only imperfectly, he is also watching us from the shadow that shields one side of his face. As in her depiction of Osman, Buckland seems to express something about

Matthew's autism, but also something about the frustration of being cut off from a child. There is not only a confusion but also a frustration expressed here – some of the children are difficult to reach. But Buckland's representation is not only of parenting and disability – all parents experience difficulty in reaching their children, the difficulty of not knowing exactly what is going on with them. So Buckland seems to be doing two things – she is showing us something that is very difficult about raising a disabled child, but she is also showing us how this difficulty is not separate from the difficulties other parents face. Buckland's pictures are also, quite simply, pictures of the children themselves. We have met Osman, and when we see the picture of his fingers on the television screen, we immediately recall the boy whose eyes lit up when he saw our laptop, and who touched our hands gently in greeting. And in the image of Matthew, as with Osman's picture, there is something of the person we met who looked at us from the side furthest away, and who paints pictures where the figures have the light eyes of the family dog.

In the photographs collected in this installation, Buckland closes the distance between spectator and spectacle when she becomes both spectator and spectacle. Instead of presenting for us, the spectators, the experiences of parents of disabled children as a spectacle, she presents her own experience. In the 'Where's Nikki?' installation her face looks out at us from the line of faces, and this transforms the nature of the work. The pictures are of 'us', not 'them'.

There is something very vulnerable about the faces at the bottom of the prints (page 30-31). The warm light and the subjects' naked shoulders, the very scale of the exhibited pictures, suggests an intimacy between 'us', the spectators, and 'them', the spectacle. It is not so easy for us as viewers to see ourselves as different from this row of people, as it might be to separate ourselves from people featured in tragic–heroic newspaper or television stories. We could be them, and maybe we are.

This raises a far more fundamental question about representation, particularly in the context of vulnerability. How do we know when we are representing other people in a respectful way? How do we identify empathy between a photographer, or any artist or writer, and the people being represented? To what extent does the fact that Buckland is prepared to photograph her own vulnerability, and that of her family, inoculate her against the possibility of appropriating the lives of others and turning them into spectacle? Of course, we can ask a similar question about the text of this book – to what extent does the fact that we have laid bare the ethical complexities of this project let us off the hook and prevent us from being seen as using other people's difficulties for our own purposes?

There are no easy answers to these questions. As viewers of Buckland's pictures, we can state that there is an empathy between the photographer and the people she photographs, that she is respectful to her 'subjects', that she works to create commonalities across the 'us' and 'them' divide, and that she demands that, as viewers, we think about ourselves and not only about a spectacle 'out there'. We can back up this claim by looking at the techniques she uses, by pointing out that she photographs herself and her vulnerabilities alongside those of others. But we cannot prove these views beyond dispute. We can compare Buckland's work with those of photographers whom we regard as less empathic, less ethical. But even this does not solve the problem. The ultimate judgement about the 'us' and the 'them' in these images lies in the ways in which viewers receive them. Similarly, judgement about the text lies with the readers.

This discussion, though, may help us in another way. This book is about disability, amongst other things. But when we begin openly to explore difference and otherness, 'us' and 'them', part of the value of that exploration is that it returns us to ourselves – we have to question how we see things and the world. And this, again, places us 'in relation' rather than 'in opposition' to the images.

1. Greg Walloch, the disabled stand-up comedian, has a sardonic take on the idea of being a gift: he describes reading about 'how someone who has cerebral palsy should "heal the family with one sweeping gesture of love?" The words like totally glared off the page at me and I thought: "You know, I don't really want that job!"' (Kabilo & Walloch, 2001).
2. Prilleltensky (2003) and Kallianes & Rubenfeld (1997), among others, suggest that the ways in which disabled women are encouraged by their parents to downplay their sexuality impacts on their sense of self-worth as adults.
3. See Mannix, 1996. Mannix's insistence on visibility, and using the 'freak' terminology, echoes other ways in which oppressed groups have taken on and transformed previously demeaning terms. In the disability field, the term 'cripple' has been re-appropriated by some disabled people; we can see similar social processes in the use of terms like 'queer', 'dyke' and 'nigger' by gay men, lesbians, and black men respectively.
4. See Arbus and Israel, 1992. It is interesting that some of Arbus's pictures no longer have the same currency. For instance, as transgender identities have become more mainstream both politically and in the mass media, it no longer seems as freakish to see a man dressed in woman's clothing as it once did.
5. See Ballen, 2002. Ballen and Hugo's work can be viewed at www.rogerballen.com and www.pieterhugo.com
6. Arbus, 1972.
7. Hevey, 1992.
8. See Mitchell and Snyder (2000) and Price (1997) for more on how documentaries can reduce complexities. And Weegee's sensationalist images of early twentieth century New York City (Weegee, 2002) are a great example of representations which marginalise the very poor; among South African examples are the images created by the South African Carnegie Commission of poor white Afrikaners, also in the early twentieth century.
9. See Price (1997) and Maxwell (1999). This does not preclude the possibility for documentary photographs to be subversive of oppressive political systems.
10. Stewart, 1993.
11. Stewart, 1993.
12. Breckenridge & Volger, 2001, p. 349.
13. Jonathan is not his real name. The names of parents and children have been changed throughout except for those of Angela Buckland, her husband David, and their son, Nikki.

where's nikki?
THE COMPLETE INSTALLATION

'Where's Nikki?' was a difficult work to visualise and articulate, as it tackles the gamut of fragile human experience around disability. I saw the value of such a process in my encounters with other parents of special-needs children, in their lives, behind the silence. I sourced families willing to disclose their journeys with their children. I was surprised by their readiness to do so and fuelled by their courage in revealing their personal realities; to recount and even re-enact their worst memories.

I was also inspired to interrupt the traditional norms of documentary photography and attempt to tell a story in another way. The images are not didactic, nor bound to any documentary 'truths'. In the prints, I have inserted images from one family's experience into those about another's story, attempting to articulate the common experiences that we share with our 'different' children. I used psychoanalysis as a basic structure to construct each family's narrative. Each story is unique and unveils the extraordinary processes of human experience – for example, a promise made by a sister to surrender her engagement to look after a child that could not walk. The broken-hearted fiancé, realising he could lose his bride, then seeks to resolve the situation and finds the miracle cure – Vaseline blessed by a Shembe high priest. The daughter walks, the marriage commences.

The 'spiritual soul searching for a cure' around our collective 'problem' was fascinating. From the diverse teachings of Islam, Christianity and Shembe, to fringe religions, are all part of our collective South Africanness. Comments such as: 'all sickness is from the devil' (from the Christian 'City of Life' teachings), and 'institutionalise your child, have another one, and get on with your life', evoke curious responses, often reflecting unkind judgements and projections made by others.

Each vertical print (page 30–31) images my response to a family's particular emotional stage: shock, grief and loss, rage, confusion, relief, acceptance and hope. The verticality of the prints, reading the images from top to bottom (or vice versa), is intended to stimulate the narrative potential in the images, and also refers to time and memory. The large scale (the installation is over 4m high, and 11m wide), unlike the preciousness and fragility of the 'Dysmorphic Series', is about asserting this material and 'making it spoken'.

In this work there are feelings of guilt, anger and despair. There is the frenetic race from one doctor to another in a desperate search for a cure, the build-up of tensions within the family, the often energy-sapping everyday management of the child and the worry about the child's future. But there is also the joy and hope that even the slightest evidence of progress brings, and with it, a greater appreciation of, and for, life itself. Every spectrum of human emotion is played out on many levels. Each situation is different and varies according to the severity of diagnosis. There is only one certainty: uncertainty. Every parent's secret dread is a 'dodgy' child.

Angela Buckland

1: SHOCK 2: LOSS / GRIEF 3: RAGE 4: CONFUSION

5: RELIEF 6: ACCEPTANCE 7: HOPE

Page 31

'his job is to fix the problem'

Encounters with the medical profession

Like many parents of disabled children, Buckland found the process of trying to get a diagnosis for her son very emotional and difficult. The process was perhaps made even more difficult by the fact that doctors were, ultimately, unable to arrive at a diagnosis. She still feels a great deal of confusion and frustration about Nikki's impairments. She and her husband have little in the way of established medical points of reference to guide their parenting or their expectations, and this makes everything more difficult. While going through the process of looking for a diagnosis, Buckland made the 'Dysmorphic Series' of images. She showed the series to the paediatrician caring for Nikki, and describes his surprise at the intensity of her feelings:

> He e-mailed me afterwards and said, 'I had no idea about the emotional side that you were talking about.' And he confessed — that sounds terrible and may be the wrong word — but he said that he had no idea. His job is to fix a problem. He sees some kind of medical problem, and it is his job to fix it.

We have been taught that medicine and science can, or should be able to, fix almost everything. And there are, of course, many ways in which medicine has been able to fix things which were once accepted as unfixable. We explain to children that the 'doctor will make it better' — this phrase is the basis of hundreds of advertisements, and lies at the heart of how many parents explain to children the value of what may be painful procedures.

The reality, though, is that doctors cannot cure everything. We may go to the doctor expecting a solution, but this is not always possible. What happens when these expectations for cure are not met? First, the doctor may feel like a failure — many people enter helping professions precisely because they want to help people. Second, the patient, or the parent of a disabled child in this case, may feel disappointed, let down, even angry. A mother in particular, who may be under a great deal of social pressure to produce a 'perfect child' as part of what is seen as the 'woman's role', may have turned to the doctor to make everything better, to save her from being seen as a deficient woman for having produced a deficient child.[1] So there is a lot contained in the fantasy that the doctor can fix everything.

What do doctors do under circumstances like this? They may heroically try to do more and more investigations to find a cause or a cure when they suspect — or even know — that this quest is hopeless. They may protect themselves from their own sense of helplessness and despair at not being able to help by trying to cut off emotionally, and by retreating into the position that because modern medicine is scientific, emotions are irrelevant to the best care of patients. They may even label parents who demand answers, as 'confused' or those who want a second opinion as 'neurotic', 'over-involved', or 'in denial'. They may pretend to themselves and to parents that disabled children who are in obvious pain and distress are not really capable of feeling pain. All these reactions, though not ideal, are human and understandable. It requires an enormous change not only on the part of doctors themselves, but also in what we expect of them, for doctors to behave differently under very difficult circumstances.

The changes that need to happen — that Buckland's work helps us see the need for — are not small. The pressure parents can put on doctors to make it all better is all the greater when parents are sometimes blamed for having disabled children. In a world in which we expect perfection and in which technologies can change so much, disability can be seen as a kind of moral failure, no less than it was seen as a kind of spiritual failure in more religious societies. Parents might be blamed for things they may or may not have done to 'cause' disability. This blame is all the more complex as there are certain disabilities which are definitely preventable and which are a direct result of what parents have done

– foetal alcohol syndrome, for example, is attributable directly to high alcohol intake during pregnancy. Disability may also be seen as a 'cross to bear' – either a type of punishment to the parent or a kind of a 'gift' given to the parents because God has decided that they can bear the pain of having a disabled child. Some of these fantasies about disability, and combinations of them, stalk all parents of disabled children, and are part of the silent context of their interactions with health professionals. It is hardly any wonder, with a wide range of social, religious and cultural prescriptions weighing on both parents and doctors, that encounters between them over children's disabilities are often difficult. We need to learn from those encounters where somehow both the parents and the doctor get it right – where it is about working together in a constructive, respectful and helpful way.

No fixes, no fixed points

If we cannot always expect a cure or a 'fix' for our difficulties, we may at least hope for a fixed way of seeing them, of making sense of them. This fixed point is also not always there. In the first panel of the 'Where's Nikki?' installation (page 30), Buckland represents complete disorientation.

She describes the first panel as an expression of the profound sense of displacement she felt when she was looking for a diagnosis for Nikki – of feeling as if she did not belong, was lost. Buckland describes the time when she first realised that Nikki might have impairments, and started looking for a diagnosis. She describes having:

> a feeling of numbness and shock...I remember being incredibly cold. It was a horrible winter and I felt so alone, so desperately isolated, and so cold. I thought, 'How do I express that photographically?'

Some of Buckland's distress was because she and her husband David could not obtain a diagnosis for Nikki. The blankness of some of the frames in this panel reflects this sense of expecting something, some meaning, and finding numbness and nothingness instead. Buckland describes this image of the hospital corridor:

> It's that feeling of looking down, and dungeons. I just had that feeling of going down from one to the next. It's like there were these tunnels, warrens, and it's how you feel, a cold, awful feeling. You notice things, but you're like a machine. You feel nothing. You're in this strange numb place.

In all this disorientation, there is a very strong wish for certainty, for reference points, for knowing what is going on. However, people do not always fit neatly into categories of disability, and this can make diagnosing more difficult. One mother we spoke to described the process of getting a diagnosis of autism for her son:

> He'll be ten in May...He's been diagnosed now for about eight years with autism. He was doing quite well until he was about one year and six months. He had even managed to learn a few nursery rhymes and things like that. And then after that, I noticed that he wasn't responding to his name. Before that, he knew his name and he would respond. He wasn't responding to his name and he was doing a lot of running around the house. Like he'd be running down the passage and back up again, and jumping on the bed. And he would do the jumping excessively...So I wasn't really sure what was going on here. And at about one year and eight months, it had become quite bad. He wouldn't respond to talk at all. But he wasn't like a zombie or anything like that. He would be noisy. Wherever he was, he would be noisy. Then we took him and had him assessed...I think it was with a psychiatrist – a child psychiatrist. And then also [a] paediatrician. But he didn't meet all the 16 or 24 criteria – however many it was. So they couldn't pinpoint on a diagnosis...oh boy, autism was totally unheard of. I'm in the medical field and I had not heard of autism until I had [my son]. So the diagnosis wasn't 'he's autistic and what do we need to do for him'.

For a paediatrician or a psychiatrist, it is important that every child be measured against a fixed set of diagnostic criteria, as a diagnosis may help in planning for the child's future, and may help in preparing parents for what they can expect. But for this mother, the experience of her child's not meeting the '16 or 24 criteria' seems like the experience, once again, of having a child who does not measure up — who does not fit properly into a known category. The emphasis on the counting of the criteria, furthermore, highlights the parent's perspective of the child becoming no more than a set of broken parts or processes — criteria which can be counted. The counting, so necessary to good care, can be experienced as so alienating to parents. For the parents we spoke to, the stress stemmed from more than the immediate business of dealing with the demands their child was making on them. It was also about the frustration of not knowing what was wrong and of not being able to respond appropriately to the child's needs, of thinking about a future which seemed so uncertain and so different from the fantasy of a child who grows up happy and healthy, and is an unambiguous gift welcomed by everyone. The stresses take their toll on all family relationships. One father we spoke to described the convoluted experience of getting a diagnosis:

> We were on the verge of divorce...because I was trying to run my business, and we had Ally screaming literally day and night. I mean, what had happened is that she would go off to sleep for maybe ten minutes at a time, and then she would have a brain seizure and she'd get a fright and wake up screaming. So we are talking ten minutes maximum. Bridget and I would spend two or three hours each during the night when we would take turns and so on. And then I would go to work in the day and Bridget would be left with the problem for the day. So it was really a nightmare for her. The records we have is that she was at a paediatrician at least once a week — sometimes twice a week. And on this particular occasion, Ally went in, and he had obviously had enough of this story thinking that we were now neurotic caregivers, and he said to us, no, Ally is actually just naughty. We should put her in her cot in the next room and close the door and just let her scream herself to sleep. And of course, we've had this now for a month or even two months, and this is the sort of response we would have every time we go the paediatrician route. This was all brought back to a colic situation, and in the meantime, she never had colic. All the time this was going on, we were trying to force things down this kid's throat just to get her to drink something or feed something. And in all this time, she was having brain seizures. So we got to a stage where Bridget said, look, I've had enough. I can't carry on like this. Put her in hospital for observation. And it was then that he turned round and said to us, no he thinks she's got cerebral palsy...He *thinks* she has cerebral palsy.

The father telling the story is very frustrated and angry at the doctor's inability to declare himself with more certainty. It would have been wrong, dishonest, and unethical for the doctor to say he knew what was going on when he didn't, but the feelings of confusion are hard for this father to bear, and he blames the doctor, at least in part, for them.

Perhaps the doctor could have been more helpful by saying 'it's hard for us all not to know'. For a doctor to make this admission, though, and to help parents by explicitly naming and sharing the load of the confusion, takes confidence and the trust that the parents will not blame the doctor for not knowing. Like other people, and especially because of the social pressures placed upon them, doctors may not feel comfortable discussing their uncertainty when others would like them to be sure.

It is easy, when we learn of doctors behaving in this way, to accuse them of not caring for disabled children and their families, and there are, indeed, some uncaring doctors. But it is much more important to realise that caring a great deal — wanting to help but feeling helpless — can also lead to what on the surface may seem to be uncaring behaviour.

Once those in positions of care recognise how unfair expectations and pressures from all sides profoundly affect them, and those who come to them, they may feel able to interact in a more vulnerable and more humane manner. When,

for example, doctors can recognise and accept the reasons why people may unrealistically expect certainty from them, which they are simply not able to provide, however much they would like to, they may begin to deal with the consequences of such uncertainty as allies and partners of the parents and the child.

Make it better

At certain times of our lives we all invest a lot of authority in doctors. This belief in doctors' abilities to make it better can verge on the religious — as is suggested in the third 'Where's Nikki?' panel (page 30). In this panel, there seems to us to be a link between religious faith and faith in the medical realm. This is most prominent in the topmost image where operating lights form an illuminated cross.

The lights, which normally illuminate a patient lying on an operating table, seem to cast their light over the mother in the photograph below. She seems to be praying, eyes cast down. Reading down the print, we see the small cross in her hand. She is held between these two crosses — the one that seems to illuminate her and the one she holds in her hand. There is the suggestion that she is not simply praying to her god but also to her doctor. This set of images resonates for us with the ways in which parents of disabled children look to authorities like health professionals to make it better, or at the very least, to make sense of what is happening.

Parents often would do anything to have their child miraculously healed of their disability. Particularly in a culturally diverse society like South Africa's, parents often try a range of traditional and alternative therapies and remedies. One parent described her belief that she could alter her child's mobility difficulties by rubbing Vaseline on her legs. Another parent described visiting a kinesiologist in order to try to understand her child's experience:

> So I have been seeing a specialist kinesiologist...She believes the mercury in his body has been a real toxic problem for him. She uses bits of his hair; it sounds like witchcraft! But it's fabulous! You walk home with the information she gathers and it's hilarious...And you just really are desperate to believe them. You know, you will hang onto anybody that comes up with something. 'Oh, this is exciting.' You will hang onto every breath.

One parent suggests that it is helpful if doctors themselves are more aware of alternative therapies, and can guide parents in their search for more information.

Sometimes doctors can make things better, but not by miracles, and not by taking away all pain, all difficulty, all impairment. One of the caregivers we spoke to described how one paediatrician's thorough examination of her child improved life dramatically for the child and for the whole family:

> I found the most stunning paediatrician, he's just brilliant...Two years ago, I took her to him. I'd heard about him and he is very well known here, so I thought, I'm just going to take her to someone totally different. Our daughter had a high temperature and she was battling with constipation. And he examined her, he checked her anus...and he showed me. She was cut so badly from all those hard stools that she actually will not want to make a stool because it's too sore. So she keeps it in and keeps it in, and that is why she gets these excruciating stomach pains. This child screams with stomach pain...you can just see how she is suffering. And we didn't know that. No other doctor has picked that up...[After he treated her] she was a different child.

The last statement — 'she was a different child' — reveals the parent's belief that the doctor is capable of profoundly changing her child. An important way in which this doctor helped this child is that he examined her thoroughly — a series of doctors had missed the fact that she was suffering from constipation. This doctor had been able to see a part

of the child's experience which is important and which goes beyond her disability. It is important, to both the child and the mother, that he took the time and trouble to look at all of the factors that might affect the child. In this mother's experience of a very caring doctor, we see the flip side of the doctor discussed earlier by an angry father. This mother has a faith in medicine and in the doctor himself that may go beyond the rational, so grateful is she for the way in which the doctor has recognised her child. He has also, it appears, recognised a need in this mother which must also go beyond the rational, a deeply felt need to be understood, to be seen. There is always the danger, though, that a doctor held in such high esteem may fall — he has, indeed, a long way to fall — but the chances are that a respectful and honest relationship between doctor, family and child may build a realistic partnership among all involved.

'It's from your side of the family'

As much as parents may blame doctors for what is outside of the doctor's control, parents are themselves often blamed for their child's disability. Caregivers and parents of disabled children often feel a great deal of shame regarding their disabled child. Parents of autistic children whom we spoke to said that sometimes they were accused publicly of not being good caregivers. For instance, more than one parent mentioned how people in shopping malls sometimes expressed their belief to parents that their children were poorly disciplined. Other parents felt that they themselves were somehow to blame for their child's disability. One mother blamed her child's disability on a fall she had had. Interestingly, the child's father was more inclined to blame negligent medical care before and during the birth itself. One mother we spoke to said that she felt that her extended family blamed her and her genetic make-up:

> Family members start looking down on you. I've had family members look at me: 'What did you do when you were pregnant? How is it that he was born like this?' And the in-laws saying: 'Well, it comes from your side of the family.'

It is not only disabled children who are sometimes judged to be inadequate but also their parents. As we mentioned earlier, women are expected to produce 'good' children, and their ability to do so adds to their own social value and that of the family. To produce children who are perceived as defective can be shaming.[2]

Society sometimes blames parents for their child's disability, and for introducing disability into the world. For instance, women who knowingly give birth to babies with impairments have been accused of being selfish and irresponsible.[3] Sophisticated reproductive technologies offer the promise of a 'perfect' child, and in this context producing an 'imperfect' child seems even more shameful.[4] In addition, there is a vast literature in the health professions that looks for links between what are termed 'risky' prenatal activities and disability in children.

Even if the illness or disability is not seen as the fault of the parent, the solutions often don't seem to include them. One family described how they felt excluded from the care of their child when their infant had a brain shunt inserted to relieve pressure in his brain. The parents were asked for their permission for this essential procedure, but were not told that the child would not be anaesthetised. They sat outside listening to the baby screaming as the operation was performed. The shock of their baby needing this operation, and the shock of the way the operation took place, is associated with their not being fully informed. Because the doctors they were dealing with did not explain everything, the parents' feelings about the invasive but essential surgery, and their feeling of not being able to help their child, are mixed up with their feelings about not being fully informed. For these parents the pain of diagnosis is all mixed up with being excluded from information about their child:

> I got handled by two orderlies when I tried to go into the intensive care unit...Ja, it was a very good hospital...but a government hospital. And I think also dealing in most cases with a lot of uneducated patients perhaps who

wouldn't question anything. So there wasn't a culture of dialogue with the physicians and surgeons. And they found us a bit threatening because we would catch them in the corridors at times. Sometimes they would give us answers, which we knew weren't exactly the story.

In a situation that already feels out of control to parents, they need the sense that they are involved in how doctors and nurses are trying to help their child. Where parents feel excluded from the medical process, it is easy for them to blame doctors not only for their insensitivity but also for the disability of the child, and for them to overlook the ways in which the doctors are trying to help. Things become even more complicated as doctors – and parents too, though for different reasons – may feel blameworthy: the parents may feel they have 'caused' the impairment, and doctors may feel inadequate for not being able to make the impairment go away, or explain why it happened.

Parents we spoke to expressed the need for a considered diagnosis, for breaking the news sensitively, and for honesty regarding the difficulties they may face in the future. What is hard and what doctors may be blamed for is that often they simply do not know. If they could discuss the not knowing and associated feelings with parents, this would help. One mother described a particularly compassionate disclosure:

> We went to go and see this professor, and my husband said to him: 'Look, I want to be told the truth. I want to be told, are we doing the right thing. Are we in the right direction because my wife is killing herself...We need to know that what we are doing is going to benefit the baby.' And he examined her. Took about half an hour to forty minutes. He just sat us down and he sat back in his chair, and tears started rolling down his face. I thought, 'We've never had that with a doctor!' And he said to us: 'I cannot tell you how difficult it is for me to tell you this, but she will never walk or talk. She will never go to school. She may still walk...She's very strong, and from here to here, she's amazing. She's strong in the balance – everything is there. But it's from here down, where there is a problem.' And I said to him, 'Not even a cerebral palsy school?' and he said, 'There will be no schooling.' I just sat there and wept. It was the worst...that night, I cried the whole night. I just couldn't accept what I had been told. It was just horrible...I just wanted to crawl into a hole.

Perhaps the fact that this doctor was also a respected professor gave him the confidence in his professional capabilities to show his vulnerability to the parents. Perhaps it was experience which enabled him to show his vulnerability. Whatever the reason, here is a doctor who has had the courage to recognise that he cannot take away the sadness the parents feel, or he himself feels. By being honest and vulnerable, he allows them to face their grief. Many parents are ashamed even of their grief – this doctor makes grief acceptable and natural. By showing that he is not afraid to feel, he communicates to the parents that he is not afraid of their feelings, that their grief may be bearable.

Disclosure and the world of health care

One set of parents we spoke to suggested that physicians making a diagnosis of impairment ought to refer parents to a trained counsellor to help them cope with the news.

> You actually learn the hard way in this country because you know...it's tough enough hearing that your child has got this problem, but you as caregivers, you are not told that this is going to take its toll on you, and we feel that it might be a good idea to go and see a psychologist – or do this or do that. You know, just so that you can keep the marriage going and support structure in place for the child's benefit.

It is a reality that there are far fewer resources in South Africa for parents of disabled children than there are in wealthier countries. It would, of course, be wonderful if there were more available for such parents, and it is important and

correct that we fight for more resources. This, indeed, is part of the motivation for this book. But we also need to recognise that almost wherever one goes, one will hear complaints about a lack of resources. The painful fact is that we all wish that if only there were something more, someone more, one more drug, operation, expert, counsellor, teacher, then the pain would go away and everything would be all right. We need to accept both that we must fight for more and that the wish for more resources may be the wish for the impossible – a complete solution to grief, confusion, pain, and the burden of care.

We earlier described a compassionate disclosure. Other disclosures are less sensitive and some are downright insensitive. For instance, another parent we spoke to described the following insensitive disclosure:

> The child psychiatrist said that he thinks that [my son] is autistic – and there is basically no future; he needs to be institutionalised. And we need to move on with our lives and maybe have another child.

In this case the doctor implies that this child is a mistake that should be hidden away. He suggests that the child be replaced with another child. He does not take into account the parents' love for their child, and that this child is not replaceable. He also fails to take into account the ways in which the parents may find their relationship with the child rewarding, and the ways in which the child may contribute to the family and to the parents' sense of self-worth.

One researcher suggests that health professionals' attitudes towards disabled individuals may be distorted by their being exposed to impairment only in medical settings. They see disabled people when they are vulnerable, as many of us are when we go for medical help. Because of this, the idea that disabled people are defective and pitiable may be reinforced for health professionals.[5]

There is, in addition, a popular cultural narrative about disabled people – in popular media disabled people are frequently represented as helpless victims or, at best, tragic heroes. Neither of these narratives takes into account the complex ways in which disability is experienced, and the complex ways in which disabled people are restricted not only in their impairment, but also by social attitudes. These narratives ignore the ways in which disabled people have fought for political empowerment, and the ways in which they define themselves in more complex ways than just being disabled. Narratives of disabled people as helpless or as tragic create a sense of the overwhelming tragic loss of human potential.

In clinical contexts the emphasis is likely to be on the disabled person's impairment and on their dependence on often unpleasant treatments[6] – on the ways in which the person is not coping rather than on the ways they are coping. This may be one of the reasons why medical personnel sometimes do not include information on how to cope effectively with a child's impairment when they disclose a diagnosis to parents. This may also be why health professionals may not discuss strategies used successfully by families to deal with difficulties associated with particular conditions. Doctors may have relatively little experience of the vast number of disabled people who live rewarding and fulfilling lives, and the often positive and personally satisfying aspects of parenting a disabled child.[7]

There is no one correct way to disclose and discuss disability with parents. The pitfalls of, on the one hand, false hope, and, on the other, undue pessimism, may both relate to genuine attempts to do the best thing. Parents and disabled people cannot and should not depend solely on health professionals – this would place an unfair burden on doctors. The experiences of other parents and disabled people can also be very important. This is not to say that every person who has a disability or a disabled child is an expert on all experiences of disability, or that every disabled person is empathic and helpful to others who are disabled. On the contrary, disabled people and their families display the same range of characteristics as everyone else. But there is a range of experiences which only disabled people and their families can know from the inside.

Beyond fixing

Parents sometimes find that their child exceeds their own, and medical, expectations. One mother told us:

> From that prediction to where we are now, it's a hell of a lot. He rides his bike outside. He sings beautifully...storms [plays] on the computer.

Another parent said:

> And when you see that smile on his face when he has achieved something, it's just beautiful. And you find that when he does something — anything little — he really gets pleased with himself, which is such a sweet thing, considering all the battles that he has to go through.

Many parents insist that their children's impairments are part and parcel of who they are and of what makes them lovable. A mother described her autistic son in the following way:

> He's growing up to be very sweet. I wouldn't change him for anything, and I can't imagine him being anything but what he is. It just won't be him.[8]

They recognise also that impairment makes up only one aspect of the child's identity. One parent, for instance, said:

> Amanda is a quadriplegic. She can neither walk nor use her hands. [But] she is an extrovert who thrives on social interaction, and almost miraculously, has achieved some speech...Her vision is also impaired by uncoordinated eye muscles. [But] she is also independent-minded and persistent in her attempts to exert her will on the world.[9]

The work of caring for a disabled child can be emotionally challenging, physically tiring and time-consuming. There is, however, a large body of research which suggests that in spite of the challenges, there may be unexpected benefits to parenting a disabled child. A researcher in the United States, herself the mother of a disabled child, found that parents rarely expressed a desire to relinquish their experience of parenting a disabled child.[10] Many mothers say that parenting their disabled children has made them stronger and better mothers. They say that the experience influences them to make positive life changes and that they feel a new sense of focus in their lives.[11] Some felt they had to reassess their priorities and some mothers sometimes extended their private caring role to the public domain, by becoming involved in advocacy work.[12] Others described positive changes in their personalities, relationships and values and others reported increased self-confidence and assertiveness, saying they were able to communicate more effectively, and that they learned how to challenge medical professionals and traditional definitions of 'expertise'.[13] Many mothers viewed their children as 'teachers', assisting them in learning compassion, patience and unconditional love.[14] There is little research into fathers' experiences of parenting disabled children. What there is suggests that fathers, like mothers, gain a sense of personal growth, and the opportunity to reconsider their values. They appreciate developing their ability to practise tolerance and sensitivity.[15] One father we spoke to expressed his sense of communicating with his severely disabled child:

> She understands when her mom and I are talking to her. When I say she understands, she knows that there's that love between us...And we'll make a couple of sounds and she'll laugh. She finds that funny you know. So there is that sort of interaction between us.

This kind of interaction is very meaningful to him; it justifies the time and effort spent in caring for his daughter.

> So I'm saying if there's that amount of interaction between us, then there must be something else possibly that hasn't been developed. So I would hate to...you know, it's easy just because it's a little difficult just palming her off and making it somebody else's problem.

He describes how caring for his daughter satisfies his own sense of himself as a good, honourable person.

> I mean, there are some kids that have been in [institutions] who went in there the day that their caregivers dropped them off, and those caregivers have never been back even for a birthday. You know what I'm saying? And I mean, those kids, they need so much love and so much attention, and they just don't get it.

For him, caring for his daughter is not just about the immediate satisfaction of experiencing her love for him, but the sense that he is doing the right thing by looking after her in the way he is.[16]

> What worries me is that we don't know what happens when we die. We don't know what's going to happen. We don't know whether there is going to be a judgement day or not.

Part of how the fathers we spoke to expressed their love for their children was by undertaking the enormous task of trying to provide financially for the child not only now but also after the parents' death.

What do we want to make better?

The experience of disability is dependent on far more than the nature of the impairment. For instance, the extent to which parents are able to take care of their disabled children depends on the financial and emotional resources they have access to.[17] The father quoted above is able to take care of his child at home because he has the emotional and the financial resources to do so. Poverty affects families of children with disabilities more severely than either poor families of non-disabled children or affluent families of disabled children.[18] Poverty makes the experience of disability worse for families through under-nutrition during pregnancy, and through limits on available cognitive stimulation, limited access to good schooling, safe and well-serviced homes. Of course, all these factors contribute significantly to family stress, which in turn affects the extent to which parents feel they are coping.[19] The main factor in whether parents find their relationship with their child satisfying is not necessarily the severity of the child's impairment.[20] What is perhaps a factor is the intensity of day-to-day caring required by the child. Researchers associate greater involvement in everyday care activities with greater parental stress.[21] This was in a sample of mothers of children diagnosed with spina bifida. The amount of support caregivers receive or give each other affects how stressful they find taking care of a disabled child. For instance, some studies suggest that if parents have confidence in their ability to take care of their child, it is less stressful.[22]

It is not unusual for parents to acknowledge religious or spiritual satisfaction in parenting their disabled child. One mother we spoke to said:

> Although I'm born a Muslim, I'm not very practically Islamic in my dress and things like that. But I believe in God a hundred percent. But I guess with both my kids, when I had them and when I was pregnant with them, I just viewed them as a gift. In my mind, I just thought that whoever they are and however they turn out, it will be for me to look after them because I just feel honoured that God had given me these gifts.

She draws strength from the idea that she was 'meant' to have a disabled child:

> But I must say, whenever I thought of kids, I always had a feeling that I will not have...like not all my children will be normal. I just had that feeling.

For her this implies not only that this is part of everything being right – being on track – but that there is a higher purpose in whatever challenges she faces. As was the case with many parents we spoke to, spirituality provides a way of making sense of things.[23]

There is something problematic, though, in the idea that a disabled child is, to use a Christian idiom, a cross to bear. There is the sense here that disability is a punishment – and that living with disability or caring for someone who is disabled is supposed to be painful and unpleasant. But to suggest that it is supposed to be this way implies that there is little that can be done. It also suggests that the experience of disability is only about impairment, when social context plays such a huge role too.

Disability is not simply a physical or mental state, defined and understood in terms of medical lists of impairments. It is also understood and experienced socially and politically. We argue, with those who support what is termed the 'social model of disability', that some of the experience of disability is about other people's problems.[24] Proponents of the social model argue that disability is,

> not a medical nor a health question. It is a policy or political issue. A disability comes not from the existence of an impairment, but from the reality of building codes, educational practices, stereotypes, prejudicial public officials...ignorance, and oppression which results in some people facing discrimination while others benefit from those acts of discrimination.[25]

This certainly appears to be true for some parents in that a substantial aspect of the stress is related to the ways in which the child is not welcome or accepted in social arenas like schools, families and even shopping malls. When they tell stories about awkward encounters in the mall, there is a sense in which they rediscover their child as being disabled against the backdrop of an unforgiving, ignorant and prejudiced public space. What is ordinary in the usual context of their family is suddenly socially unacceptable, disgusting perhaps, downright deviant even. This is about more than a lack of wheelchair accessibility. This is about people coming up to you and telling you that you are a bad parent because your autistic child is running around or is making a loud noise. Parents also rediscover their child as disabled when they cannot find a school for him or her. Although post-apartheid policy encourages inclusive schooling, parents tell us that mainstream schools regularly refuse entrance to disabled children.

Given our discussion thus far, it may be surprising that for some parents of disabled children, medical spaces can be places where they feel that they are supported in ways that they are not in other public spaces. One study describes how mothers enjoy going to their children's physiotherapy group because it gives them a chance to interact with other mothers of disabled children. She says that it gives them a chance to feel normal for a change. The medical space that she describes is one where parents feel a very welcome sense of not being different – a respite from often feeling freakish.[26]

In the 'Stickytape Juice Collection' Buckland reveals the little secrets of hidden bibs and velcro, and with that, the big secret: 'I wish my child fitted in.' There is something similar between these attempts to hide away the child's disability, and the desire one mother to draw attention to her autistic child's disability: she longs not to have to explain why he behaves unusually, or to put up with other people's unspoken criticisms of her child-rearing practices when

he seems out of control. Wishing for a sign to hang around his neck that says: 'I am autistic', her child is eventually given a T-shirt by a sympathiser that reads 'I'm autistic — what's your problem?'[27]

In hiding aspects of the child's disability, parents may, paradoxically, be attempting to make their child more visible. In some spaces the child is reduced to being nothing more than a collection of impairments, deficiencies that distract from that which is really different and special about each child. Parents may be saying: 'See the child, and not the disability.' Similarly, the mother of the autistic child in the story above seems to be asking for a kind of recognition that sees beyond immediate prejudice, that sees her son more completely — as having an impairment and as being good enough.

1. For a discussion of the politics of mothering a disabled child, see McKeever and Miller, 2004.
2. See McKeever & Miller, 2004.
3. Blumberg, 1994
4. Landsman, 2003.
5. Marks, 1999; Byron et al., 2005.
6. Blumberg, 1994.
7. Blumberg, 1994; Green, 2002, 2003; Parens & Asch, 2003.
8. Green, 2003, p. 11.
9. Green, 2003, p. 23.
10. Landsman, 1998.
11. Landsman, 2000.
12. Wickham-Searl, 1992; Traustadottir, 1992.
13. Wickham-Searl, 1992.
14. Landsman, 2000.
15. Hornby, 1992.
16. There are many reasons why some parents may choose to institutionalise their children and we do not want to comment here on whether institutionalisation is predominantly 'good' or 'bad'. This is a complex issue. We are simply reflecting the views of one of the parents we interviewed.
17. For example, see Rodriguez & Murphy, 1997; Gottlieb, 1997; Cuskelly, Pulman, & Hayes, 1998.
18. Park et al., 2002.
19. Park et al., 2002.
20. See Britner et al., 2003; Glidden, 1991; Cuskelly et al., 1998; Button et al., 2001.
21. Havermans, 1991.
22. Again, see Cuskelly et al., 1998 and Havermans, 1991.
23. Some families we spoke to also found their interactions with religious communities very stressful.
24. The social model of disability was developed in response to the medical model's conceptualisation of disability. Supporters of the social model locate disability outside the body, in society; specifically, disability is constructed as the product of disabling social barriers (Landsman, 2003). The fundamental principle underlying the social model is that impaired people are disabled by, or excluded from, society because social structures are not organised in ways that take account of their needs and enable their participation (Tregaskis, 2002).
25. Pfeiffer, cited in Landsman, 2003.
26. Green, 2001.
27. This recalls the re-appropriation of labels like 'freak' by Mannix and others, discussed earlier.

where's nikki?

THE OUTTAKES / SINGLE IMAGES

The large-scale prints for 'Where's Nikki?' were limited in terms of the number of images that were suitable for the installation. A number of images not used in the seven prints, together with a few repeats, were ideally suited for use as independent images for this book. Here is a selection.

Angela Buckland

Page 48

Page 52

Page 54

What To Do About Your Brain-Injured Child

Page 58

Page 71

over
'the dog barked the roof'
LUKE OSBORNE age 11

Family dreams and nightmares

Buckland's work is unusual in that it expresses both positive and negative experiences of parenting a disabled child. Parents have complex reactions to the diagnosis of their child's disability. Sometimes they feel that their grief about their child's disability – no less than their joy in their child – is disregarded. In this chapter we look at the broad range of feelings parents may have about their disabled children.

Fractured ideal

In the second print of the 'Where's Nikki?' installation, the third image down is of fractured glass (page 30). The image is framed in close-up so that the fractured view could be the lens itself. The broken, distorted view in this image is our own. The picture refers to a particular story, but the distortion that describes a traumatic moment could also describe our ways of using this story – something it is as well to discuss before going on to tell the story and to look at the pictures in more detail.

Buckland is not a documentary photographer, and the images collected here do not pretend to be factual representations of particular experiences. The installation contains photographs from more than one family and Buckland reinterprets and borrows from all the families, as she reinterprets the stages of grief identified by psychiatrist Elizabeth Kubler-Ross, to tell her own story about parenting Nikki.[1] She enlarges her own family album by including these intimate images of other families.[2] She uses the photographs to tell a bigger story of disability in South Africa. The story of the fractured glass is no longer simply Gwyneth and Tony's story.

The story goes that Gwyneth was distraught after the trauma of hearing that her child is chronically disabled. She forgot to put the handbrake on in her car. She and her husband describe the incident:

> Tony: There's a car wash at work with massive glass panels. Just in front of it...when Gwyneth comes to see me she parks her car and she comes in. And she drove in – in a state as usual – climbed out and closed the door. Locked the door and walked into the office. And as she walked into the office, I looked out of the window and the car was rolling down. She had come in in a state as usual...
>
> Gwyneth: We weren't even talking if you remember.
>
> Tony: Ja. Parked the car and hadn't put on the handbrake. She left it in neutral because it was a diesel. And the thing started rolling down the hill and it rolled into this big glass panel of the car wash.
>
> Gwyneth: Thank God there were no people...there was a child sitting there and Tony thought the child [was in danger]...so he went off at me. You see, that's the other thing he doesn't do, but he went off at me. I'm not in the car...
>
> Tony: I am running at the side of the car but I can't open the car because she's locked it. I'm now trying to stop this car.

But he does not manage and the car rolls into the glass panel, fracturing it. The destruction that follows a simple

forgetting, the slow motion understated disintegration of how things should be speaks to the numb chaos that many parents of disabled children traverse after finding out that their child is disabled.

Buckland describes how she understood the story: 'She hadn't slept for five days. It was a wake-up call that she was not okay.' Another parent describes the sense of losing her bearings in the aftermath of finding out that their child is disabled:

> At the time you don't know. You think everything is fine. I didn't sleep through the night for four years...I was exhausted. There were times when I wished my child was dead. When my child was sick I used to think 'something's got to give. Maybe it should be my child'...That's when you know you're not okay.

The idea of a fractured ideal runs through the print. The cot in the second image is off kilter, and the blurred rocking horse seems to be moving out of reach – the images of idyllic childhood are unstable (page 30). The print evokes the overwhelming grief at the realisation that there will be no perfect child and no perfect childhood. We might imagine the line between the top two images to be a bar separating surface from interior, conscious from unconscious. If we do so, the careful niceness of the magazines and glass coffee table are made less safe by something that looks like a dream. When we know that the perfect child pictured in the fourth image is severely disabled, the photograph seems less a picture of perfection than a protection of our sensibilities, or perhaps a way of protecting the child from our exploitative curiosity. It preserves the 'ideal' that is also there in the first image, and that Buckland suggests is fragile. The understatement conveys the loss all the more powerfully. The silent scream we imagine shattering the glassy silence is all the more vivid for our having to imagine it.[3]

Yet, like the icons in the print, the concept of an ideal childhood is itself unstable – we usually do not agree on exactly what it is and, when we do find common ground, the ideals change over time and between different geographical and cultural locations. The romantic idea of the perfect innocence of the child, and the perfect parent's ability to provide perfectly everything, is just that – a romantic notion that is inadequate to the real joys and failures of parenthood. The goal of providing an ideal childhood is a tantalising and ultimately impossible one.

Of course, with the loss of the idea of offering someone an ideal childhood there is also the loss of the idea of being an ideal mother, an ideal father. Implied in this print is not just the grief of losing the child you dreamed of, but also the parent you dreamed you might be. There is in these pictures what one author has referred to as 'the melancholy in between the ideal and the real'.[4] The space between the cot and the fleeing rocking horse is the space of what might have been.

Typically, when parents find out that their child is disabled, they grieve for what they believe might have been. Powerful feelings of grief come from losing the child one was expecting to have – the ideal child that one imagined one would have. One researcher describes this loss as the 'trauma of dashed expectations'.[5] This is not the more simple grieving for the child who has passed away. The child who has 'died' for parents of disabled children is imaginary, so they do not get the ritualised community support that people receive when someone actually dies. Despite their feeling of loss – a loss that includes grieving for what they feel the child has lost – the child is still present. Equally, the positive feelings they may have about their child may not be receiving the rituals of support associated with welcoming a new child into the world. Alternatively, they are often encouraged to focus on the 'specialness' of their child to the exclusion of expressing difficult emotions such as grief, anger or frustration. Feelings of loss and grief are sometimes not considered acceptable in families. But this is not to say that parents do not experience loss in relation to finding out that their child is disabled. One mother we spoke to described her sense of not being allowed to be depressed about things not turning out the way she had hoped:

My mother...said to me, 'What is going on with you? Why are you like this with your husband? What's happening? You don't treat him well.' And you know, all I wanted to do was cry. I was just crying all the time because I was so mentally drained and physically tired. And I couldn't tell this to anybody even though my mum and I are so close. I dare not say to her that I'm going through depression!

A number of parents have expressed their distress at being given a poem entitled 'Heaven's Special Child' following the diagnosis of child impairment; a text which implies that God chooses certain people to be parents of disabled children because of their exceptional parenting ability, and which describes the child as a 'special gift'.[6] These kinds of responses to child impairment were perceived by mothers as being patronising and as belittling their experience of shock and loss.[7]

The loss of the 'ideal' family

In some ways family snaps are always romantic — the wishful creation of a fantasy of family. The family we all wish we had is right there in the happy smiles at Christmas and at weddings. In this make-believe space there is no abuse, no illness, no anger, no sadness, no tension.[8] This ability to fashion a desirable family should not be taken lightly. In a lot of ways the archive — the family album — actually creates what it pictures. Looking back over the years, the reams of happy snaps capture a very real part of being a family — the sense of belonging, the sense of investment in something that lasts longer than the human lifetime.

Buckland's photographs are brave in how they make visible the spectre of unhappy times. In this she acts against what photograph analyst Marianne Hirsch describes as 'the willful construction of family photographs'.[9] Buckland does not insist that being in a family is easy or always happy. Pretending that families are always happy is not particular to families with disabled children. To some extent all families censor certain realities out of their 'public' memories, or the memories that are on display, and perhaps this censorship is necessary to the project of being a family. The disintegration that is inherent to admitting the dark side of families threatens the idea that families are useful. Including images of our grandfathers in alcoholic binges or our grandmothers in bulimic fits is antithetical to the idea that families are generative spaces — which they are also. Buckland does not flinch from representing families' nightmare times.

Even casual family snapshots tell certain stories about a family. For instance, the decision to pose in front of a monument rather than on a lawn reveals something about how that family imagines itself. The decision not to pose is also revealing about the fantasy the photographer has about the family. Families use photographs to tell a certain story about themselves. How the photographs are displayed and ordered also reveals something of the fantasy of a family. It is not only what is in the picture that is revealing but what is left out. Is there a member of the family regularly missing from pictures? Is the photographer always the same person, and so always absent from the pictorial record? South African photographer Marasela dramatises her mother's absence in a series of photographs of herself, heavily pregnant, seated next to an empty chair. The photographs are less about what is in the picture than about what is out of the picture — Marasela's absent mother.[10]

What may also be missing from the family album are the difficult times the family has had or is having. Traditionally, family snaps are of happy, presentable moments. We are unlikely to whip out a camera when there is an argument raging — 'look how dad's mouth stretches when he is shouting at me'. Typically, family snapshots celebrate rather than document the family. Even where pictures represent a solemn or sad moment — such as perhaps funeral photographs — these are typically of rare occasions, not of everyday dysfunction.

Buckland herself comments that it would be easy to picture her difficult child in peaceful moments that could safely be framed and put up on the living room wall, but in the next moment he is trying to run away or feeling irritable.

What is left out of, or put into, family snaps tends to reflect social norms of what fits and does not fit the idea of an ideal family. For some people, disability does not fit into their idea of a family. Some families find that they are encouraged to exclude their disabled child. They may find that the birth of a disabled child is not greeted with the same welcoming ritual as other births are. The birth or diagnosis of a child with an impairment may not be accompanied by the social or cultural rituals that publicly acknowledge motherhood. For example, parents are sometimes not congratulated on the birth of their child in the conventional way — through gifts or celebrations — nor is the infant admired. Many mothers of disabled children feel that this lack of acknowledgement reduces their motherhood to something lesser, 'other', or different from 'real' motherhood. Some parents even see this lack of acknowledgement of the birth of a baby with impairments as negating the existence of the baby. One mother said:

> When she was born and people heard there was something wrong, like, the congratulations disappear. You don't get any of that. It's like you don't have a baby.[11]

Parents sometimes feel the loss of a kind of social standing and feel stigmatised. A premature baby's mother articulates this eloquently:

> And...I realised how much I missed out on having my first baby. Having the family come in to see her, to see the child...All the rituals. I missed out on showers. I missed out on everything. There was nothing that was a pleasure about her birth, and even after her birth. You know, you don't send out announcements, because what's there to announce? That you had a one-pound-five-ounce baby, you know? It's all those rituals. They shouldn't mean anything, but they do.

Families feel a powerful need to 'clean up' their family by excluding the disabled child when entering into public spaces. Parents we spoke to said that people often didn't expect or understand disability, and that such people failed to see the funny side of awkward encounters. One mother tells of a humorous incident involving her autistic son at a local shopping mall:

> We went with his dad to the shopping mall. We went to do something, and he was holding his dad's hand. At the edge of the mall there's like a row of tiles demarcating the shops entrance from the passageway. So he was following the tiles and he came to a halt because there were two ladies standing in front of him.
> He moves everything out of his way. So unfortunately, he put his hands forward and moved the one woman out of the way. She was wearing a mini skirt, and when she turned around, what she saw was Pravesh's dad, and she thought that he had put his hand between her legs! She was horrified! And then she looked down and she saw Pravesh. And Pravesh's father didn't know what was happening because he wasn't paying attention to his son. It was just Pravesh's hand between this woman's legs and trying to get her out of the way! She screamed and jumped out of the way. Pravesh just carried on. He didn't really stop to look at her. He was just following the line of the tiles. At one stage, we did quite a lot of apologising for Pravesh. With quite a lot of people, he tends to get into their space and they feel very uncomfortable. He doesn't know about people's space. He thinks that all is just free, and whenever he does that, people get very nervous. Not with kids. Kids are fine. It's mostly with older folk. They get very nervous: 'Get him out of my space.' But he doesn't really do anything. He would just maybe stand next to you and lean against you, or he would come and caress your face. But just that he was in their space.

Siblings sometimes find it very challenging to be in public with their disabled brother or sister. One family we spoke to described how the ritual of going to eat out at a steakhouse had become difficult for the severely disabled child's sister, because as she got older she was becoming increasingly aware of how people stared:

> Mother: She's getting embarrassed now; she's eleven. Friends are staring. 'Why are they looking? Why is Ally knocking her head?' You try and have breakfast and she starts pooing – so she starts pressing. The minute you go to a restaurant, she sits and she starts pressing in her pram. And everyone looks because it's a loud sound. You know, when you have constipation…

> Father: She screeches because it's hard for her to go to the toilet.

> Mother: So of course, that is embarrassing. It's embarrassing for us. And she is only eleven, so you can see she looks down straightaway, and she looks to see who is looking. It started happening a few months ago and I could pick it up. I said: 'Come, let's go for breakfast.' She said: 'Mummy, is Ally coming with?' So I said: 'Ja, she's coming with us.' And I could see she didn't look herself, but I left it. And then I was busy in the kitchen and she came to me, and she said: 'Mummy, please don't get cross with me but I don't feel like going for breakfast.' And that is all she said. So I said, 'No that's fine' because I knew it was Ally. And so I didn't get upset with her. I just went to her dad, I said: 'Just go and have a chat to her because I think that is the situation. But don't get worked up' – because he sometimes gets worked up with her. It's difficult, because you are trying to be there for both girls, and you want your family together. But at the same time, you've got to look at her feelings…And he chatted to her, and she just cried. She wouldn't exactly tell you what it was – but I knew.

Even within the extended family, there can be a lack of understanding. One mother we spoke to was horrified to realise that members of her family were mocking her son:

> I notice even with our immediate family, they make fun of him and it hurts a lot. And you know when they are family members you think, 'God! Which place did you come from?' And you don't know how to respond to them because you've got this smile on your face that's just about sagging! And you can't be angry with children because they don't know what they are saying. But they are saying what they've heard from adults.

In the 'Stickytape Juice Collection' (pages 16–21), Buckland presents the ways in which parents and caregivers have lovingly tried to make it easier for their children to fit in. This impulse makes the bright images somewhat poignant for us. The cheerful T-shirts make us feel a little sad as they recall the pain of not fitting in – something we have all experienced. One of the traditions of representation that Buckland draws on in these pictures is that of advertising. The bright colours, bright lighting on objects dead centre in the frame recalls clothing catalogues or fashion photography. These are places where parents shop not only for mass-produced clothing but for mass-produced ideas about what it means to be a child or a parent.

Our ideas about what an ideal child, an ideal parent or an ideal family look like, are to some extent generated in mass-media representations of these ideals. Magazines, and advertisements regularly present us with beautifully dressed, colour coordinated, physically perfect children and parents whose houses are flawlessly decorated and spotlessly tidy. What seem like the very same children and parents appear in movies and television dramas and sitcoms where we usually find out that they always have supportive friends, enough money, and that their troubles are easily resolved in the course of, at most, two hours. Buckland's pictures recast the glossy fantasies with disabled children and parents of disabled children. In doing so the images subvert the glossy fantasies of ideal families that do not include disability.

Reclaiming the 'ideal' family?

If the second and fourth prints in the 'Where's Nikki?' installation (page 30) suggest the loss of the idealised parent and child, the last two suggest finding those ideal figures again. Reading the sixth print (page 31) vertically we see support emphasised. Sibongile's leg never touches the ground: there is a tantalising space between her foot and the floor, even when it is mirrored in shadow as in the print's second image. Where her feet might be touching the ground in the third image, they are blurred with light and so the image is not clear. We are reminded of something David, Buckland's husband, said about his own son – that he touches the ground so lightly and asks for so little. Sibongile seems magical in these images, levitating above the ground like an angel or a saint. Her courageous spirit is idealised in these images. She becomes iconic of the physically imperfect ideal child.

What is also valorised in this print is the kind of support Sibongile receives. She is carried in the first image, supported by a stool in the second. The vertical line of her leg is repeated again and again, and when we expect to see it repeated in the fourth image we see instead the light touch of hands stretching horizontally across the frame. The support is not only about helping her to move around, but an emotional and spiritual support. When we know that Sibongile's mother carried her child on her back long beyond infancy despite being ridiculed by passers-by, we feel a pride in the mother's physical and emotional strength. When we know the story of how, after Sibongile's mother's death, Sibongile's aunt gave up her engagement to look after her sister's child, this seems represented in the light touch of fingers, affirming the caregiving bond. In the second last image the adults in Sibongile's life embody the idealised parent, providing the kind of support and acceptance that we would all be proud to provide to a child.

In the final print (page 31), it seems that the lost child has been found, too. Jonathan is depicted in an intimate moment with his mother. The images of Jonathan and his mother recall, more than any of the other imagery, the family snapshot – mother and child in happy times. Jonathan's mother regards him, while he looks away slightly. She sees him as none of the other parents or caregivers are depicted as doing. In the next picture down he is seated in the centre of the frame with 'ugly' shoes thrown away in favour of more fashionable shoes, not associated with the institution of disability. He is not eclipsed by his disability. He is not lost, he is found. In his looking so happy – so loved and so confident – his caregivers also seem ideal. This is the only print where both father and mother are portrayed, and this, too, idealises a kind of parenting where both mother and father are active in loving their child.

Questioning the ideal

Going to the 'Where's Nikki?' exhibition, one mother found seeing her experience portrayed in the prints extremely emotional:

> It was very sad for me to see. When we went and saw it, I just sobbed and sobbed and sobbed.

Not only are stories woven together from many sources, but the 'Where's Nikki?' prints portray moments in a family's history that are in many cases past. Viewing these images, stories distilled to the purity of 'grief', 'joy' or 'confusion', it is tempting to believe each family to be iconic of these emotions – always joyful, always grieving. Just as we might grimace at old haircuts and old boyfriends in old photographs, the emotions associated with each family in these pictures are not necessarily current. When we asked Jonathan's parents how they felt about being the 'after' of 'before and after', they laughed and said that things were not so simple. They said they sometimes felt uncomfortable with the idea that they had reached an ultimate destination where they no longer feared or despaired. Buckland draws on the Kubler-Ross stages of grief – denial, anger, bargaining, depression and acceptance[12] – but she does not insist that the process follow that course. The prints form a grid that can be read across as well as from top to bottom.

There is something uncomfortable for us in the idea that there is a journey from disorientation to knowledge, from grief to joy, from broken families to fixed families. In the academic literature, parental grieving was believed to involve three separate stages: the 'initial crisis reaction', accompanied by shock, disbelief and denial; a period of emotional disorganisation, characterised by anger and/or depression; and finally, the stage of emotional reorganisation, involving realistic caring for and nurturing of the disabled child.[13]

This, in turn, suggests that there is a right order to having feelings, that none should be skipped and that once you have 'passed through' each successive stage it is over – no more difficult feelings. More recently, researchers believe that these stages may not always occur in the same order, and that parents may revisit certain feelings. In other words, grieving, like any emotional process, is not a simple linear progression. Nor can family identity be fixed at a particular point in time: it is a work in progress.

The space between the idea of the ideal family and the actual family is a productive one, where people experience frustration and strive for solutions. We think there is an intrinsic similarity between this productive process and the process of considering difference, as we have done in this book. The space between the ways in which people experience life in the same way as others do, and in different ways, is a productive space, where the need for understanding is experienced.

We hope that this text has not been a revelation of disability and of parenting disabled children as an intrinsically different experience of life. Rather, we hope that we have represented the tension between the ways in which experiences associated with disability are both of being different and being the same. We do not feel that we have resolved the issues raised in this text, by Buckland and by the parents we spoke to – and it would be a pity if we had. Rather, we hope that the space opened up by what we have written here, by Buckland's photographs and by what parents have said will be opened up further, to include more voices.

1. See Kubler-Ross, 1969.
2. This is similar to how photographer Jo Spence enlarges her 'family album' in her photographs of women in a cancer ward (Hirsch, 1997).
3. Thanks to Virginia MacKenny of Michaelis Art School, University of Cape Town, for the idea of the image conveying a sound.
4. Naruyama et al., 2004.
5. Landsman, 1998, p. 76.
6. The poem is by Massimilla, 1986. For more on this, see Felker (1991).
7. Interestingly, parental relationships with professionals with the highest status, most power and most professional experience, have been described as the most problematic (Murray, 2000).
8. Kuhn, 2005.
9. Hirsch, 1997.
10. Schmahmann, 2004.
11. Landsman, 2000.
12. Kubler-Ross, 1969.
13. Landsman, 2000, p. 174.

shadow catching

'Shadow Catching' is the most recent photographic work about my/our journey with Nikki. These photographs come a few years after 'speaking out', and into a quieter space. Nikki has always been fascinated with his shadow; it is a fleeting and short-lived moment, one of many endearing activities unique to him. After a period of contemplation and stirred by Jung's ideas about our inner shadow, I realised the combination was an obvious photographic device to exploit. Thoughts about decisive moments, lightness, darkness and shadows in-between are a given within the emotional spectrum of disability. These are also the traits of photography.

There exists the clichéd stereotype idea that special-needs children are angels (perhaps they fell – minus their wings – did God forget about them?). When Nikki dances with his shadow, there are split-second moments which make Nikki unrivalled, mysterious and particular. He will never quite 'fit' and cannot conform to society's norms. Our challenge, his pleasure, sometimes my jealousy: the images play with these ideas – they could be read as literal, romantic, triumphant, childlike, metaphorical or even obscure.

Angela Buckland

Photographic Print Details

Dysmorphic Series 1999 *pages 2 – 5*
Silver gelatin selenium toned prints
Edition of 5
240mm x 180mm

Stickytape Juice Collection 2002 *pages 16 – 21*
Duratrans prints, light display case, acrylic
Edition of 3
955mm x 800mm

Where's Nikki? 2002 *pages 30 – 31*
Primary Installation: Lambda prints on photographic paper
4000mm x 1270mm per print
Single edition

Secondary Installation: Lambda prints on photographic paper
2000mm x 630mm per print
Edition of 3

Where's Nikki? 2002 *pages 46 – 73*
Outtakes/single images: Silver gelatin selenium toned prints
508mm x 405mm per print
Edition of 5

Shadow Catching 2005 *front cover, i, ii, 84 – 87*
Silver gelatin selenium toned prints
Edition of 5
508mm x 405mm

Photographs are available, each handprinted, numbered and signed by Angela Buckland.
email: barland@yebo.co.za
www.angelabucklandphotography.com

Acknowledgements

The production of this book would not have been possible without generous financial support from the Royal Netherlands Embassy.

Professor Linda Richter, Executive Director of Child, Youth, Family and Social Development Research Programme (CYFD) of the Human Sciences Research Council had the originality of vision and insight to see that the possibility of an innovative book through a collaboration between the social sciences and the arts. Without Linda's vision and drive, this book would not have come into being.

Valerie Sinason of the Clinic for Dissociative Studies in London provided very helpful insights to the process and ethics of writing this book.

Our thanks to everyone at HSRC Press, especially Mary Ralphs, Garry Rosenberg, and Karen Bruns, for steering us through a difficult process, sticking with it, and allowing this unusual product to emerge. Lizette Phillips of CYFD provided consistent and helpful technical support.

Angela would like to thank:

Hirt & Carter for scanning the negatives.

The Jagot, Jordan, Ledingham, Osborne and Sithole families for their valuable contribution and willingness to share their stories over the years.

For technical assistance: Brode Vosloo, Science, Slade Mansfield and Garth Walker.

For additional support: Stefan Bremmer, Virginia MacKenny, Jo Ractliffe and Joanne Lees.

The memories of: my father Roy Buckland, Buyi Sithole and Yvonne Jordan.

And Nikki, Christine and David. With love.

References

Arbus D (1972) *Diane Arbus*. New York: Aperture
Arbus D & Israel M (1992) *Diane Arbus: Magazine work*. New York: Bloomsbury
Ballen R (2002). Outland: Roger Ballen. *Katalog*, 14: 24–29
Blumberg L (1994) The politics of prenatal testing and selective abortion. *Sexuality & Disability*, 12: 135–153
Breckenridge CA & Volger C (2001) The critical limits of embodiment: Disability's criticism. *Public Culture*, 13: 349–357
Britner PA, Morog MC, Pianta RC & Marvin RS (2003) Stress and coping: A comparison of self-report measures of functioning in families of young children with cerebral palsy or no medical diagnosis. *Journal of Child & Family Studies*, 12: 335–348
Button S, Pianta RC & Marvin RS (2001) Mothers' representations of relationships with their children: Relations with parenting behavior, mother characteristics, and child disability status. *Social Development*, 10: 455–472
Byron M, Cockshott Z, Brownett H & Ramkalawan T (2005) What does 'disability' mean for medical students? An exploration of the words medical students associate with the term 'disability'. *Medical Education*, 39: 176–183
Case S (2001) Learning to partner, disabling conflict: Early indications of an improving relationship between caregivers and professionals with regard to service provision for children with learning disabilities. *Disability & Society*, 16: 837–854
Cuskelly M, Pulman L & Hayes A (1998) Parenting and employment decisions of parents with a preschool child with a disability. *Journal of Intellectual & Developmental Disability*, 23: 319–332
Erikson E (1971) Identity: *Youth and crisis*. London: Faber and Faber
Felker KS (1991) Are children with disabilities 'special gifts'? Mothers' views. *Counseling & Values*, 36: 58–61
Fox DM & Lawrence C (1988) *Photographing medicine: Images and power in Britain and America since 1840*. New York: Greenwood Press
Glidden LM (2002) Parenting children with developmental disabilities: A ladder of influence. In JG Borkowski (Ed.) *Parenting and the child's world: Influences on academic, intellectual, and social-emotional development*. Mahwah, NJ: Lawrence Erlbaum
Gottlieb AS (1997) Single mothers of children with developmental disabilities: The impact of multiple roles. *Family Relations*, 46: 5
Green SE (2001) 'Oh, those therapists will become your best friends': Maternal satisfaction with clinics providing physical, occupational and speech therapy services to children with disabilities. *Sociology of Health and Illness*, 23: 798–828
Green SE (2002) Mothering Amanda: Musings on the experience of raising a child with cerebral palsy. *Journal of Loss & Trauma*, 7: 21–34
Green SE (2003) They are beautiful and they are ours: Swapping tales of mothering children with disabilities through interactive interviews. *Journal of Loss & Trauma*, 8: 1
Grosz E (1996) Intolerable ambiguity: Freaks as/at the limit. In RG Thomson (Ed.), *Freakery: The cultural spectacle of the extraordinary body*. New York: New York University Press
Havermans TE (1991) Mothers' perceptions of parenting a child with spina bifida. *Child: Care, Health and Development*, 17: 259–273
Hevey D (1992) *The creatures time forgot: Photography and disability imagery*. London: Routledge
Hirsch M (1997) *Family frames: Photography narrative and postmemory*. London: Harvard University Press
Hollis S & Sinason V (1993) *Bob tells all*. London: Gaskell
Hollis S & Sinason V (2005) *Jenny speaks out*. London: Gaskell
Hornby G (1992) A review of fathers' accounts of their experiences of parenting children with disabilities. *Disability, Handicap & Society*, 7: 363–374
Kabilio E & Walloch G (2001) *F**ck the disabled*. Los Angeles: Mad Dog Films
Kallianes V & Rubenfeld P (1997) Disabled women and reproductive rights. *Disability & Society*, 12: 221
Kubler-Ross E (1969) *On death and dying*. New York: Scribner
Kuhn A (2005) *Family secrets: Acts of memory and imagination*. London: Routledge

Landsman G H (1998) Reconstructing motherhood in the age of 'perfect' babies: Mothers of infants and toddlers with disabilities. *Signs*, 24, 69–99

Landsman G (2000) 'Real motherhood', class, and children with disabilities. In H Ragone & F Winddance Twine (Eds), *Ideologies and technologies of motherhood: Race, class, sexuality and nationalism*. New York & London: Routledge

Landsman G (2003) Emplotting children's lives: Developmental delay versus disability. *Social Science & Medicine*, 56: 1947

Mannix DP (1996) *Freaks: We who are not as others*. San Francisco: Pocket Books

Marks D (1999) *Disability: Controversial debates and psychosocial perspectives*. Oxford: Taylor & Francis

Maxwell A (1999) *Colonial photography and exhibitions: Representations of the 'native' people and the making of European identity*. New York: Leicester University Press

McKeever P & Miller K-L (2004) Mothering children who have disabilities: A Bourdieusian interpretation of maternal practices. *Social Science & Medicine*, 59: 1177–1191

Mitchell DT & Snyder SL (2000) Talking about *Talking Back*: Afterthoughts on the making the documentary *Vital Signs: Crip Culture talks back*. In S Crutchfield & M Epstein (Eds.), *Points of contact: Disability, art and culture*. Ann Arbor: University of Michigan Press

Murray P (2000) Disabled children, parents and professionals: Partnership on whose terms? *Disability & Society* 15: 683–698

Naruyama A Ishida S & Von Senger A (2004) *Dr Ikkaku Ochi collection: Medical photographs from Japan around 1900*. London: Scalo

Ostman RE (1996) Photography and persuasion: Farm security administration photographs of circus and carnival sideshows, 1935–1942. In RG Thomson (Ed.), *Freakery: Cultural spectacles of the extraordinary body*. New York: NYU Press

Parens E & Asch A (2003) Disability rights critique of prenatal genetic testing: Reflections and recommendations. *Mental Retardation & Developmental Disabilities Research Reviews*, 9: 40–47

Park J Turnbull AP & Turnbull III HR (2002) Impacts of poverty on quality of life in families of children with disabilities. *Exceptional Children*, 68:151–170

Price D (1997) Surveyors and surveyed: Photography out and about. In L Wells (Ed.), *Photography: A critical introduction*. New York: Routledge

Prilleltensky O (2003) A ramp to motherhood: The experiences of mothers with physical disabilities. *Sexuality & Disability*, 21: 21–47

Rodriguez CM & Murphy LE (1997) Parenting stress and abuse potential in mothers of children with developmental disabilities. *Child Maltreatment: Journal of the American Professional Society on the Abuse of Children*, 2: 245–251

Schmahmann B (2004) *Through the looking glass: Representations of self by South African women artists*. Johannesburg: David Krut

Siebers T (2001) My withered limb. In S Crutchfield & M Epstein (Eds.), *Points of contact: Disability, art and culture*. Ann Arbor: University of Michigan Press

Sinason V (1992) *Mental handicap and the human condition*. London: Free Association Books

Sinason V (1993) *Understanding your handicapped child*. London: Rosedale Press

Stewart S (1993) *On longing: Narratives of the miniature, the gigantic, the souvenir, the collection*. Durham: Duke University Press

Thomson RG (1996) Introduction: From wonder to error – a genealogy of freak discourse in modernity. In RG Thomson (Ed.), *Freakery: Cultural spectacles of the extraordinary body*. New York: New York University Press

Traustadottir R (1991) Mothers who care: Gender, disability, and family life. *Journal of Family Issues*, 12: 211–228

Tregaskis C (2002) Social model theory: The story so far. *Disability & Society*, 17: 457–470

Waldby C (2000) *The visible human project: Informatic bodies and posthuman medicine*. London: Routledge

Weegee (2002) *Naked city*. New York: Da Capo Press

Wickham-Searl P (1992) Mothers with a mission. In PM Ferguson (Ed.), *Interpreting disability: A qualitative reader*. New York: Teachers College Press

Published by HSRC Press
Private Bag X9182, Cape Town, 8000, South Africa
www.hsrcpress.ac.za

First published 2006

© in the text and layout 2006 Human Sciences Research Council
© in the photographs 2006 Angela Buckland

All rights reserved. No part of this book may be reprinted or reproduced or utilised in any form or by any electronic, mechanical, or other means, including photocopying and recording, or in any information storage or retrieval system, without permission in writing from the publishers.

ISBN 0-7969-2159-8

Copy editing by Michael Morris
Design and typesetting by Garth Walker, Orange Juice Design

Photographic credits
Page iv Albie Sachs used with the kind permission of David Goldblatt
Page 08 used with the permission of Greenwood Press
Page 12 used with permission of the National Library, South Africa

Distributed in Africa by Blue Weaver
PO Box 30370, Tokai, Cape Town, 7966, South Africa
Tel: +27 (0) 21 701 4477
Fax: +27 (0) 21 701 7302
email: orders@blueweaver.co.za
www.oneworldbooks.com

Distributed in Europe and the United Kingdom by Eurospan Distribution Services (EDS)
3 Henrietta Street, Covent Garden, London, WC2E 8LU, United Kingdom
Tel: +44 (0) 20 7240 0856
Fax: +44 (0) 20 7379 0609
email: orders@edspubs.co.uk
www.eurospanonline.com

Distributed in North America by Independent Publishers Group (IPG)
Order Department, 814 North Franklin Street, Chicago, IL 60610, USA
Call toll-free: (800) 888 4741
All other enquiries: +1 (312) 337 0747
Fax: +1 (312) 337 5985
email: frontdesk@ipgbook.com
www.ipgbook.com

Angela Buckland Photography
email: barland@yebo.co.za
www.angelabucklandphotography.com

ORANGE
JUICE
DESIGN